IMAGES
of America

CLEVELAND'S FLATS

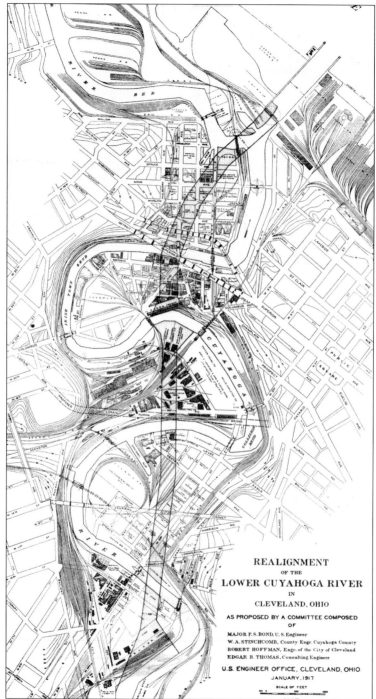

REALIGNMENT
OF THE
LOWER CUYAHOGA RIVER
IN
CLEVELAND, OHIO

AS PROPOSED BY A COMMITTEE COMPOSED
OF

MAJOR P.S. BOND, U.S. Engineer
W. A. STINCHCOMB, County Engr. Cuyahoga County
ROBERT HOFFMAN, Engr. of the City of Cleveland
EDGAR B. THOMAS, Consulting Engineer

U.S. ENGINEER OFFICE, CLEVELAND, OHIO
JANUARY, 1917

SCALE OF FEET

Engineers have been scratching their heads over how to manage the Cuyahoga since the first settlers came to Cleveland in the late 1700s. One plan from 1917 would have drastically altered the flow of the river as well as the appearance of the Flats. While the U.S. Army Corps of Engineers does maintain the river's depth through dredging, no scheme as ambitious as this one has ever been launched. (Cleveland Press Archives—CSU Library Special Collections.)

IMAGES
of America

CLEVELAND'S FLATS

Matthew Lee Grabski

Published by Arcadia Publishing
Charleston SC, Chicago IL, Portsmouth NH, San Francisco CA

Printed in Great Britain

Library of Congress Catalog Card Number: 2005935037

For all general information contact Arcadia Publishing at:
Telephone 843-853-2070
Fax 843-853-0044
E-mail sales@arcadiapublishing.com
For customer service and orders:
Toll-Free 1-888-313-2665

Visit us on the internet at http://www.arcadiapublishing.com

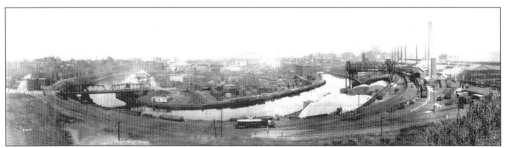

This image from 1921 is rather unusual in that it is one of the few glimpses of the Irish Town Bend while it still contained houses. Many of Cleveland's Irish immigrants resided in the shanties that clung to this hillside overlooking the Flats. These ramshackle houses would soon disappear as Cleveland's Irish population dispersed across the city and eventually into the suburbs. (Cleveland Press Archives—CSU Library Special Collections.)

CONTENTS

ACKNOWLEDGMENTS

This little endeavor would not have been possible without assistance from many corners. I would like to thank my family and friends for helping me navigate through my first book project. Also, a round of thanks to my friend and fellow Arcadia author, Tom Matowitz. Be sure to keep an eye on the skies for his book on Cleveland's air races. A huge debt is owed to my fellow *William G. Mather* crew member Robert Vance for his kind donation of pictures to this work. The vast majority of the images in this book came from the Special Collections at the Cleveland State University Library and I would like to thank the collections director, William Barrow, for allowing access to this treasure trove. And speaking of special collections, a massive thank you goes to Lynn Duchez Bycko for her wonderful assistance. And finally, I would like to dedicate this work to my late father, Lee R. Grabski. Thanks Dad!

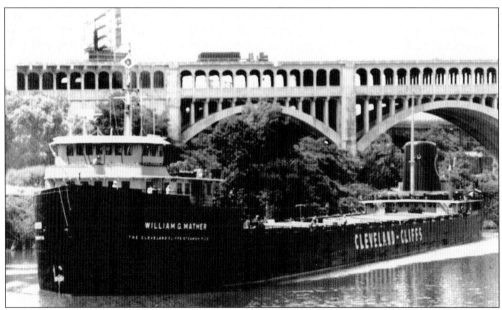

A fully-loaded *William G. Mather* navigates past the Detroit-Superior Bridge in the mid-1970s. (*William G. Mather* Collection—CSU Library Special Collections.)

INTRODUCTION

The Flats may be the most colorful region within Cleveland, Ohio. The names associated with the people and places of the Flats are unforgettable: Collision Bend, Whiskey Island, Sherwin-Williams, and Rockefeller. Additionally, the area has served as a representative for Cleveland as a whole. When the Flats does well, so does the city.

Of course, times have not always been pleasant for Cleveland and its Flats. Booms and busts, windfalls and depressions have marked the area's history, much like any other northern industrial city. But somehow, someway, Cleveland and its most unique district have survived.

The Flats are actually where Cleveland begins. They served as the landing site for Moses Cleaveland and his party from Connecticut in 1796. Cleaveland came to the far reaches of the Western Reserve to find locations suitable for settlement. Cleaveland felt that, swampy conditions aside, the region along the Cuyahoga River would make a solid place for settlers from the east.

Cleaveland did not hang around for long, however, allowing Lorenzo Carter to be the first true permanent white settler when he arrived in 1797. Others soon followed Carter and it would not be long until something resembling a village was formed. By the 1820s, however, most folks chose to set up housekeeping a bit further from the swamps of the Cuyahoga.

Things really picked up for Cleveland and the Flats with the completion of the Ohio and Erie Canal in the 1830s. Goods and people found their way along the canal from Portsmouth in the south of the state all the way to Cleveland. And, with the city's location on the southern shore of Lake Erie, Cleveland almost instantly became a booming port as goods could be transferred from canal boats to lake boats and back again.

With the Civil War, Cleveland handled all matters of items to keep the Union Army fighting. Many a merchant made a decent profit while dealing with the federal government. Among this set was a young man named John D. Rockefeller who, along with his partner, an Englishman named Maurice Clark, operated a rather successful commission business along the Cuyahoga.

Rockefeller and Clark also branched into the nascent oil refining business, which actually proved more profitable than trading bulk goods. Rockefeller and Clark would split in 1865, but both did quite well for themselves, especially Rockefeller.

As oil refineries sprouted up along the Cuyahoga, another industry began to make itself know in the late 1800s: steel. Cleveland's proximity to iron ore, coal, and limestone reserves made it an ideal location for steel production. In addition to steel and oil, one could also find paint and chemical plants and lumber yards as well as a number of other industrial concerns appearing in the Flats.

By the early 20th century, Cleveland was a solid economic power. With cities such as Akron, Buffalo, and Chicago, Cleveland helped make up what was perhaps the greatest industrial region

in the history of the world. The might of this region was one of the deciding factors in World War I as the United States helped equip its allies before joining the war itself in 1917.

The 1920s saw continued prosperity in the Flats as businesses grew to unprecedented dimensions. One only needed to look at the number of new ships sailing the Cuyahoga (many over 600 feet long) to see that the area was doing very well.

The good times did not last, however, and Cleveland, like most every other city in the country, fell hard in the Depression. Business slowed to a crawl in the Flats as the nation sank further and further into economic disaster. The call to war-time duty would rescue the Flats, however, as its industrial power became essential in the fight against the Axis.

Economic success raged in the Flats on throughout the 1950s. With nothing but a high school diploma, a person could earn a good sum of money while working for an establishment like Republic Steel.

The 1960s began where the 1950s left off, but change would be in the air. Slowly, very slowly, foreign competition began to make itself known. Also, many people were abandoning Cleveland for homes in the suburbs.

While these factors may have been subtle, one thing was not—pollution. For decades, Clevelanders had allowed all types of waste products to fall into the Cuyahoga. The city's residents had even grown accustomed to the occasional fire on the river when various unidentifiable slicks burst into flame. But it was becoming increasingly harder to live with or ignore the problem.

A fire in the summer of 1969 caught the nation's attention and city leaders suddenly picked up the pace to clean up the Cuyahoga. By this point however, pollution and an eroding job base had began to take their toll on the Flats. While steel was still made and ore boats still plied the river, the Flats simply looked tired throughout the 1970s.

Fortunately, plans appeared to convert old industrial buildings into residential and entertainment sites. Work intensified on cleaning up both the river and the landscape. The fruits of this labor began to pay off in the later part of the 1980s. For the first time in its history, the Flats became a bona fide tourist spot, and the area became the city's number one party venue.

The din has died down a bit in recent years, but one can still find nightlife in the Flats. Overall, however, city planners are examining ways to diversify the Flats experience. Current plans call for expanded housing, more family-related entertainment locations, a movie theater, and even a grocery store.

This then, is where we stand in the Flats now. Let us journey back and see some of the aspects of how we arrived here.

One

1870–1945

The Evolution of an Industrial Valley

In 1863, the firm of Andrews and Clark Company built its first oil refinery. The company consisted of Samuel Andrews, Maurice, Richard and James Clark as well as a certain young man by the name of John D. Rockefeller. Crude oil would be boiled here to produce ten barrels of naptha and kerosene (gasoline was a waste product of the process) per day. Rockefeller would buy out the Clarks in 1865 and would go on to found the Standard Oil Company five years later, around the same time as this photograph was created. (Cleveland Press Archives—CSU Library Special Collections.)

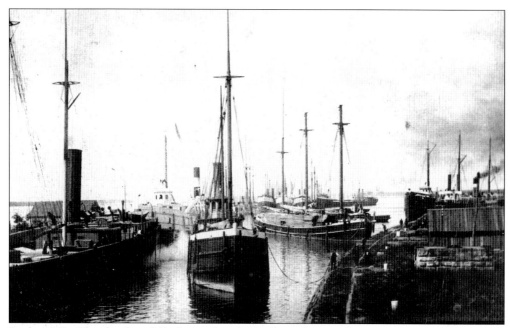

By the 1870s, Cleveland would be host to hundreds of vessels every shipping season. An assortment of steamers and sailing ships crowd the mouth of the Cuyahoga in this image. (Cleveland Press Archives—CSU Library Special Collections.)

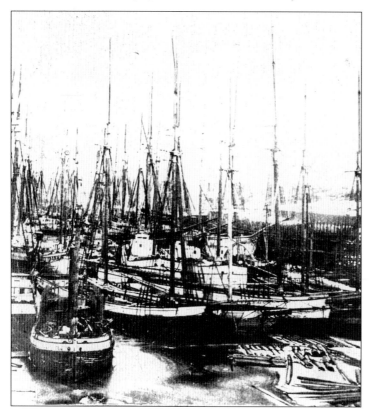

The Great Lakes were carved out by glaciers, and ice returns every winter to try and reclaim the inland seas. Vessel navigation halts during the winter months and ship owners take advantage of the time off to refit their ships. (Cleveland Press Archives—CSU Library Special Collections.)

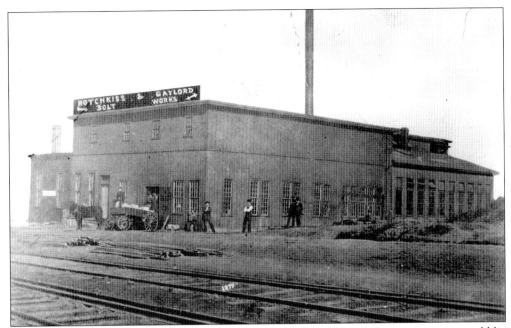

Steel has long played a role in the history of the Flats. One of the earliest companies would be the Hotchkiss and Gaylord Bolt Works, seen here during the late 19th century. (Cleveland Press Archives—CSU Library Special Collections.)

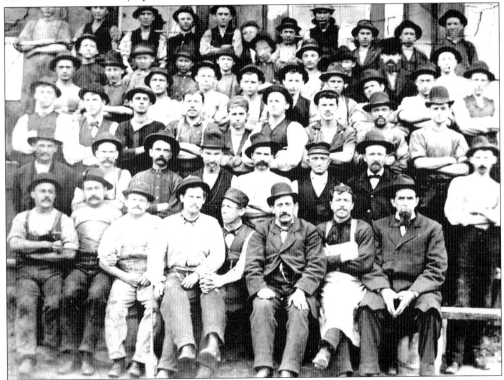

A collection of blacksmiths from Hotchkiss and Gaylord is pictured here. (Cleveland Press Archives—CSU Library Special Collections.)

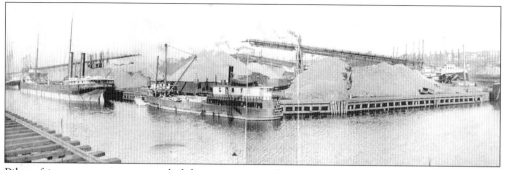

Piles of iron ore tower over early lake steamers in this image from the beginning of the 20th century. (Cleveland Press Archives—CSU Library Special Collections.)

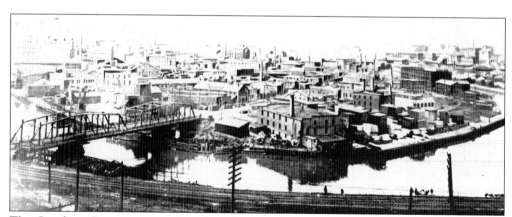

The Cuyahoga River moves rather like a large snake as it winds its way to Lake Erie. As it does, it switches back on itself several times, forming peninsulas such as this one. At left is the Columbus Street dual-swing bridge. No other bridge in the world resembled this one before its construction in 1895. (Cleveland Press Archives—CSU Library Special Collections.)

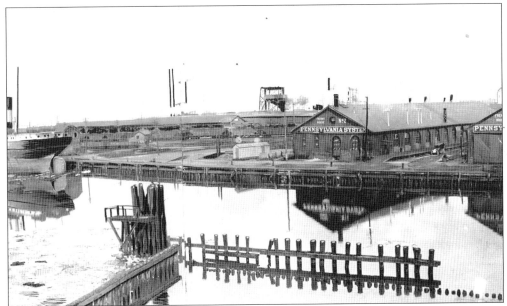

Believe it or not, the Cuyahoga does finally get to the lake. The river's mouth is one of the few straight stretches along its course. In the early 1900s, the Pennsylvania Railroad had freight houses set up along the east bank of the Cuyahoga's terminus. Note the lake boat in winter lay-up to the left and the early automobile (very likely a Ford Model T) in between the buildings. (Cleveland Press Archives—CSU Library Special Collections.)

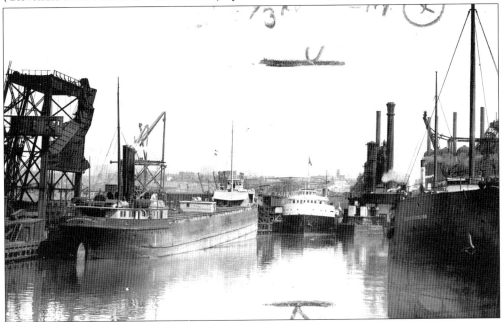

It is 1911 and, while the *Amazon of Fairport* and the *George H. Gorliss* go about their affairs, the steamer *St. Clair* finds itself jammed between the pilings of the Erie Railroad Bridge. The *St. Clair*'s 56-foot beam was apparently just a bit too wide to fit through this part of the Cuyahoga. The boat would be freed and would sail until 1961. (Cleveland Press Archives—CSU Library Special Collections.)

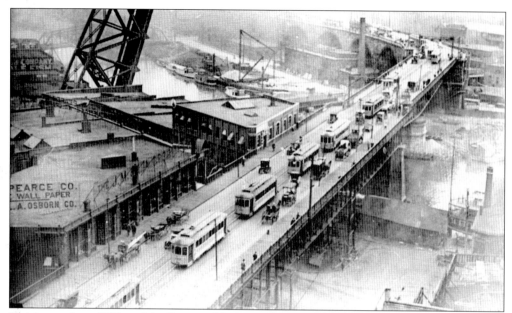

This image from 1912 is of the Superior Viaduct, which would be completed in 1878. The bridge allowed traffic to pass from Cleveland's west side over the Cuyahoga and into downtown. It stood over 3,000 feet in length and had a 332-foot-long center span that would pivot in order to permit boats with tall superstructures to pass. (Cleveland Press Archives—CSU Library Special Collections.)

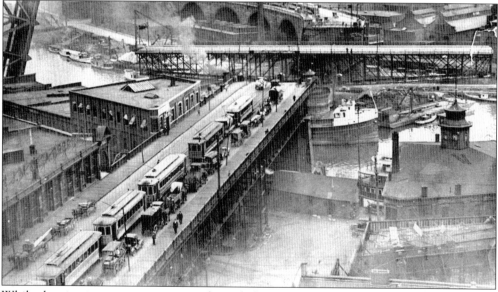

While the pivoting center span certainly made life easier for sailors, folks on the viaduct had a much more aggravating experience. Wagons and street cars would be stopped dead in their tracks (usually for five minutes or so) an average of 300 times every month. A new high-level span would be finished in 1918 in response to this problem, and the old viaduct was closed in 1920. Although much of the Viaduct would be demolished to create space for new buildings and to widen the Cuyahoga, a 600-foot-long section still remains on the river's west bank. (Cleveland Press Archives—CSU Library Special Collections.)

Great Lakes tug boat crews are often regarded as the best in the world. Part of that reputation comes from their work along the Cuyahoga. Here is a tug in action in 1919 as it uses brute force (note the blast of smoke as the tug's engine pounds away) to help a freighter make a turn along the Cuyahoga. (Cleveland Press Archives—CSU Library Special Collections.)

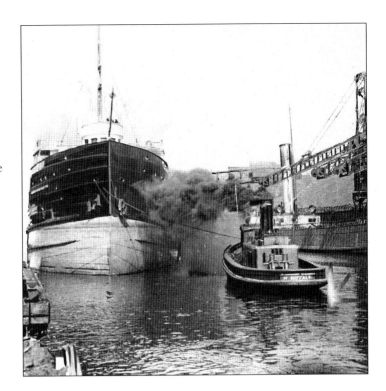

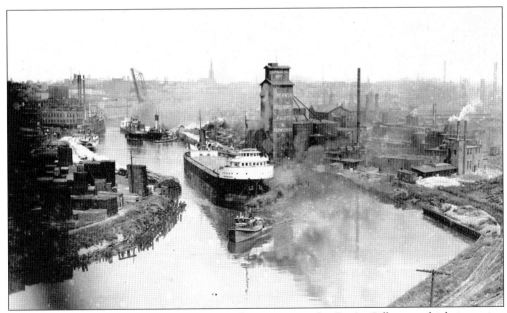

Another tug boat at work is shown here. This time it is the *D. A. Gillmore*, which is towing the steamer *Frank Billings* in 1920. The *Frank Billings* measured in at 444 feet long and would work until the 1960s. Keen-eyed readers will notice the Silver Stacker (A type of Pittsburgh Steamship Company boat, so named because of their distinctive silver smoke-stacks) sailing past a center-mounted swing bridge in the background. (Cleveland Press Archives—CSU Library Special Collections.)

At work in this image are two examples of the final word in ore boat unloading technology (at least until self-unloading ships became the standard), the mighty Hulett ore unloaders. Invented in the 1890s by Clevelander George Hulett, these massive machines had an operator actually sitting over a calm-shell bucket device. This eliminated the need for men shoveling in the cargo holds of a ship as the Hulett could very precisely drop in and scoop out cargo. The biggest Hulett buckets could remove 20 tons of cargo in one shot. The skyscraper rising in the background is the Terminal Tower, once the tallest building in the nation outside of New York City. (Cleveland Press Archives—CSU Library Special Collections.)

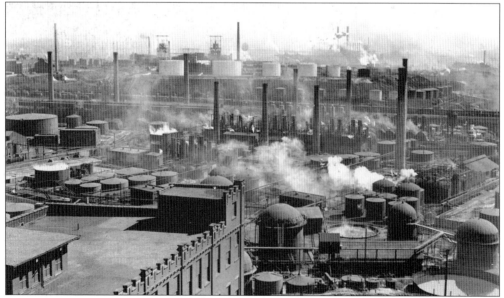

Remember the No. 1 Refinery? By 1927, this is what had become of Standard Oil's operations in the Flats. While oil lamps (and hence kerosene to fuel them) were not quite the rage they had been in Standard Oil's early days, the company still managed to eke out a living by providing the nation's automobile owners with that old waste product—gasoline. (Cleveland Press Archives—CSU Library Special Collections.)

A different view of Standard Oil's sprawling Cleveland works. (Cleveland Press Archives—CSU Library Special Collections.)

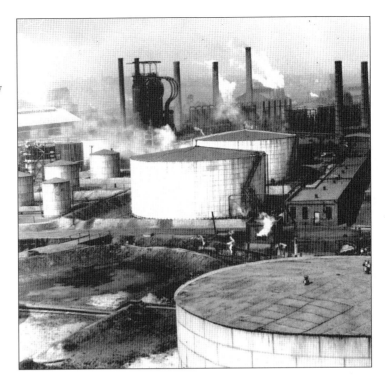

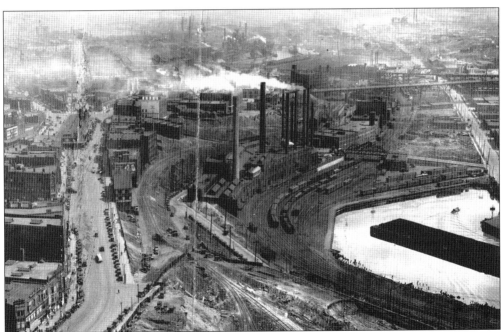

This 1927 picture was taken from what was probably the highest vantage point in downtown Cleveland at that time; the skeleton of the new Terminal Tower. Although this image is nearly 80 years old, one can still see many of the features shown. Most recognizable is the severe curve in the Cuyahoga that is referred to as Collision Bend. (Cleveland Press Archives—CSU Library Special Collections.)

Navigating the Cuyahoga through the Flats has usually meant waiting for bridges to swing or be lifted out of the way. The structure in the foreground is a Scherzer rolling lift-bridge that was used for rail traffic until 1956. Behind the rail bridge is the Center Street swing-bridge. This bridge, the last swing type left in the Flats, was built in 1901 and lies very near to where Moses Cleaveland landed in 1796. Soaring majestically over all is the Detroit-Superior Bridge. (Cleveland Press Archives—CSU Library Special Collections.)

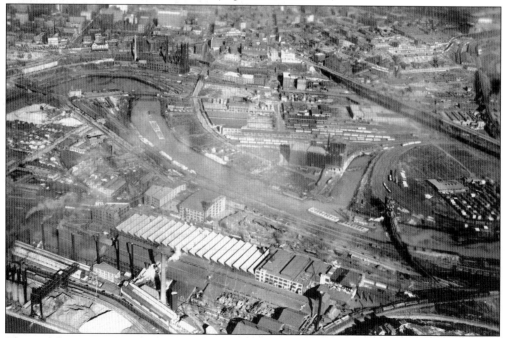

The undulating nature of the Cuyahoga can again be seen in this image taken in 1928. Note how the river comes back around in the lower left-hand corner of the photograph forming this peninsula. (Cleveland Press Archives—CSU Library Special Collections.)

Cleveland would be hit hard by the Great Depression and many residents suddenly found themselves homeless. Shanty towns, or Hoovervilles, became a common sight around the city. This particular Hooverville was located on Whiskey Island. The Terminal Tower, Cleveland's most recognizable skyscraper and only five years old at the time of this photograph, rises in the background. (Cleveland Press Archives—CSU Library Special Collections.)

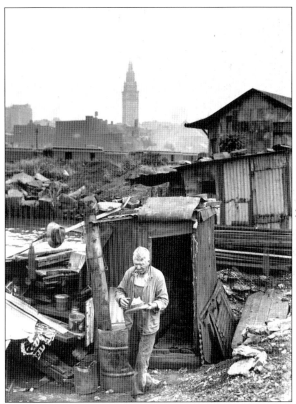

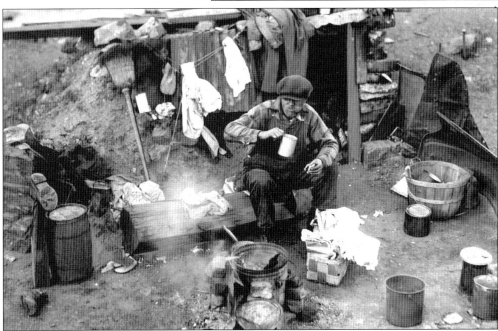

This man would not be alone as thousands of other people across the nation would be forced to set up temporary homes such as this one during the Great Depression. (Cleveland Press Archives—CSU Library Special Collections.)

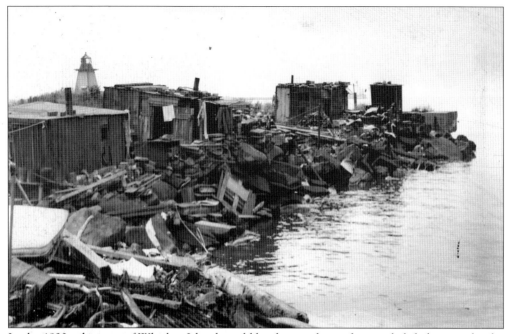

In the 1930s, this area of Whiskey Island would be the new home for people left destitute by the Depression. Today the area is a cheerful public park with virtually no evidence of the shelters that once stood there. (Cleveland Press Archives—CSU Library Special Collections.)

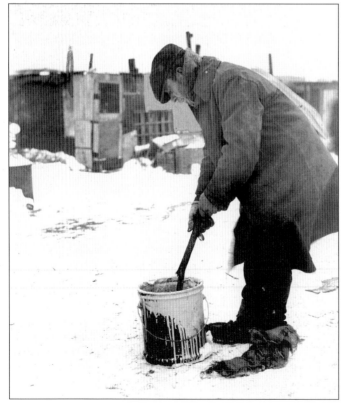

Cleveland winters are notoriously cold and snowy and they would seem even worse during the Depression years for those left homeless. This man has tied sacks around his feet in an attempt to fend off frost bite. (Cleveland Press Archives—CSU Library Special Collections.)

A man looks to the distance for some glimmer of hope. (Cleveland Press Archives—CSU Library Special Collections.)

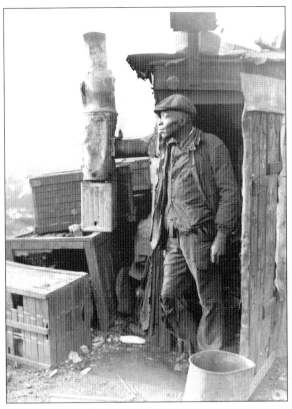

Even though the country was sliding deeper into the Depression, some businesses would manage to carry on. Republic Steel would be founded in 1930 by Cleveland businessmen Cyrus Eaton and William G. Mather. Eventually Republic Steel would grow into the nation's third largest producer of steel with some 9,000 employees. (Cleveland Press Archives—CSU Library Special Collections.)

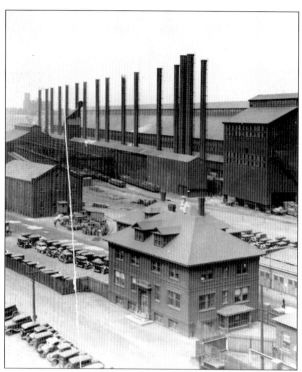

A portion of the Republic Steel works early on in its career is shown here. (Cleveland Press Archives—CSU Library Special Collections.)

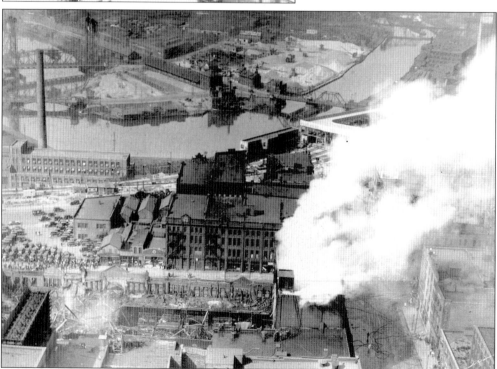

The Northern Ohio Lumber Company was among several lumber companies that was located in the Flats. A fire in May 1930, however, would cause extensive damage to the complex. (Cleveland Press Archives—CSU Library Special Collections.)

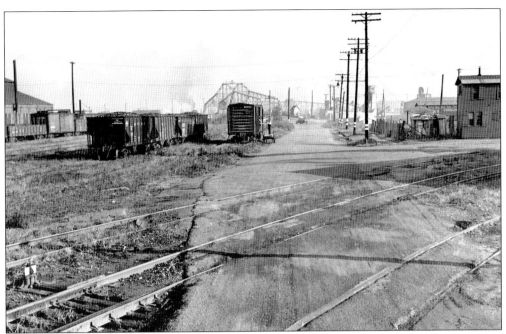

This view from the 1930s captures River Road looking east. Ontario Stone, a company that deals in materials such as limestone, now occupies the space to the left of the road. (Cleveland Press Archives—CSU Library Special Collections.)

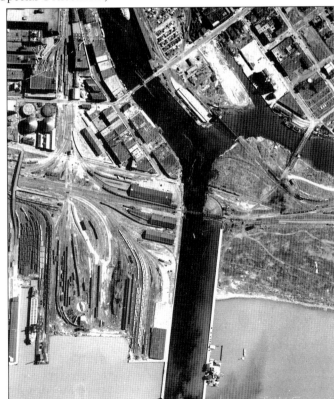

A 1931 aerial view that graphically demonstrates the effects of pollution in the Cuyahoga. If this image were in color, the river would have a reddish hue caused by iron ore dust. (Cleveland Press Archives—CSU Library Special Collections.)

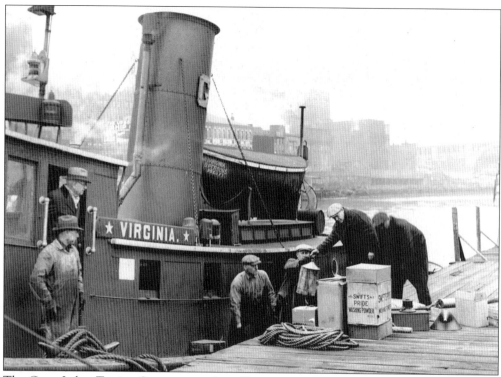

The Great Lakes Towing Company tug boat *Virginia* is working as a supply boat in 1932. The items being loaded will be taken to a water intake valve known as the "crib." The crib was built in the late 1800s and is still in service today. It lies approximately three miles off of Cleveland's shore where it takes in water for one of the city's treatment plants. In days past, a crew would be stationed on the crib for several months at a time, thus the need for the food and equipment that the *Virginia* will bring. The crib's pumping equipment would eventually be automated, eliminating the need for manpower. (Cleveland Press Archives—CSU Library Special Collections.)

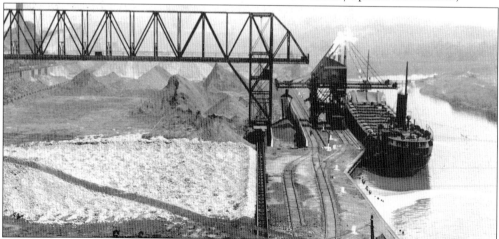

It would be rare at almost any other point in the history of the Flats to see a freighter alone on the Cuyahoga. But, since this photograph was taken during the Depression, it is a wonder that the Cleveland-Cliffs Iron Company steamer *Negaunee* (seen at the Otis Steel docks) has any work at all. (Cleveland Press Archives—CSU Library Special Collections.)

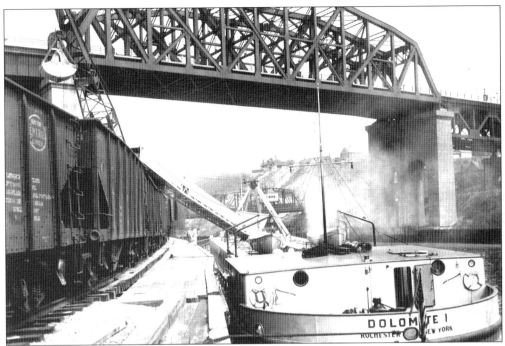

The Flats have seen a multitude of vessels pass through over the years. Few would be as unique as this one, the *Dolomite I.* Built in 1933 by the Dolomite Corporation, this small self-unloading ship was designed to sail from Great Lakes ports to the eastern seaboard by using the New York State Barge Canal. It would be bought by Nantucket Sound Transport and renamed the *Alkaliner* in 1941 shortly before being acquired by the United States government for service in World War II. The ship would meet its end in the Gulf of Mexico, the victim of a German torpedo. (Cleveland Press Archives—CSU Library Special Collections.)

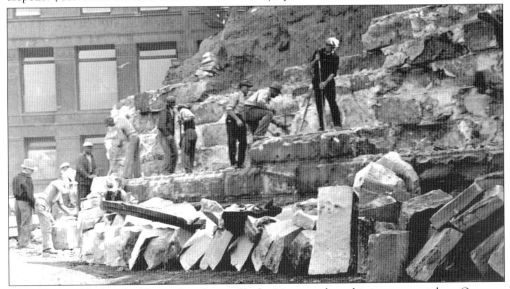

The Superior Viaduct had been closed to traffic for 14 years when this image was taken. One can imagine how difficult dismantling this span, with its massive slabs of stone, would be as crews did much of the work by hand. (Cleveland Press Archives—CSU Library Special Collections.)

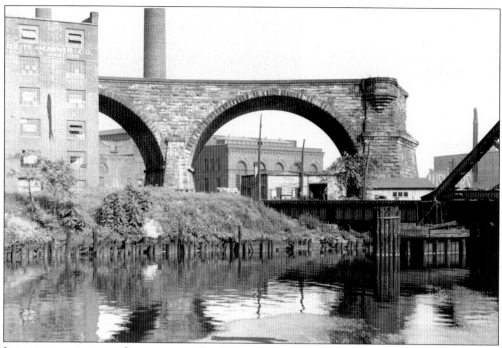

Its center span now only a memory, the Superior Viaduct's arches serve as frames for a street car power house (later to become an entertainment facility) located on the west bank of the Cuyahoga. (Cleveland Press Archives—CSU Library Special Collections.)

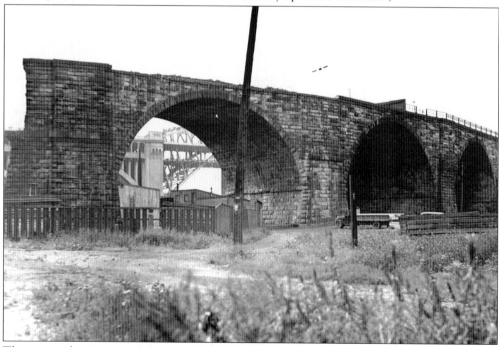

This is another image of the viaduct's remains. On this side, the span's replacement, the Detroit-Superior Bridge, can be seen through the arch closest to the left. (Cleveland Press Archives—CSU Library Special Collections.)

Many scenes in the Flats, which can never be replicated as locations and landmarks are lost to history. A modern photographer could produce a close facsimile of this 1935 image, however, as many of these features still remain. The buildings to the left still stand and are in service as part of Cereal Food Processors. The bridge overhead is the Detroit-Superior span and the bridge section to the right is part of the Center Street swing bridge. Lake boats still navigate through this section on a regular basis as well. (Cleveland Press Archives—CSU Library Special Collections.)

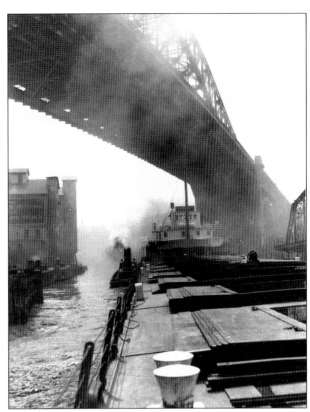

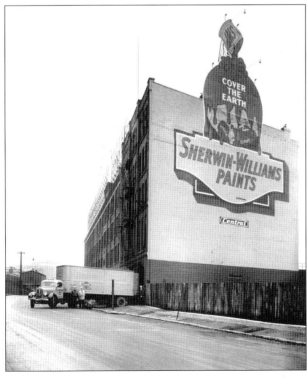

The Sherwin-Williams Company commenced operations in Cleveland in 1866. Nine years later, they would begin to sell ready-mixed paints directly to customers, thus revolutionizing the industry. Sherwin-Williams would take another leap forward in 1935 when they loaded five tons of truck and trailer paints into this tractor-trailer. The destination for the paints would be Los Angeles and this would be the first direct motor freight shipment from Cleveland to Los Angeles. (Cleveland Press Archives—CSU Library Special Collections.)

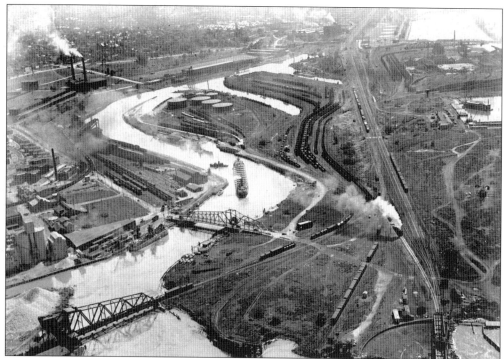

The area to the right of this photograph is known as Whiskey Island. While it is technically a peninsula, Whiskey Island has a long and colorful history. Irish immigrants would settle here in the mid-19th century. It has also been the base of operations for a distillery (hence its name), a hospital, ship yards, a salt mine and, perhaps most famously, iron ore unloading docks. (Cleveland Press Archives—CSU Library Special Collections.)

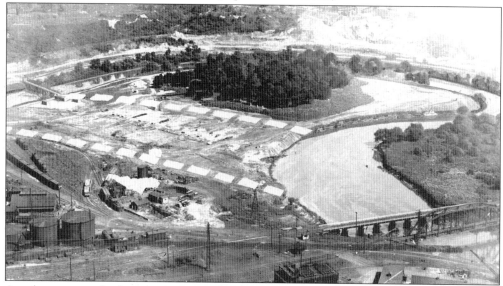

Another attempt by humans to tame the "Crooked River" is shown here. This particular project was photographed in 1937 as the Works Progress Association attempted to make a cut in the Cuyahoga south of the Clark Avenue Bridge. (Cleveland Press Archives—CSU Library Special Collections.)

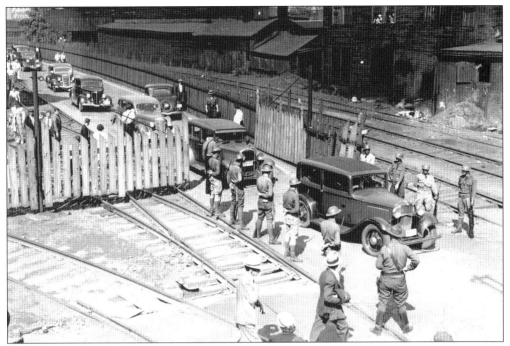

For seven years, Republic Steel had operated as a non-union shop. By July 1937, however, the workers' desire to unionize had reached a boiling point. The result was the famed Little Steel Strike. Violence flared at Republic Steel's facilities in both Cleveland and Youngstown, Ohio. Injuries occurred at both locations and two workers would die in Cleveland. The National Guard would eventually be called in to help restore order. Here we see Guardsmen monitoring traffic entering a part of the Cleveland works. (Cleveland Press Archives—CSU Library Special Collections.)

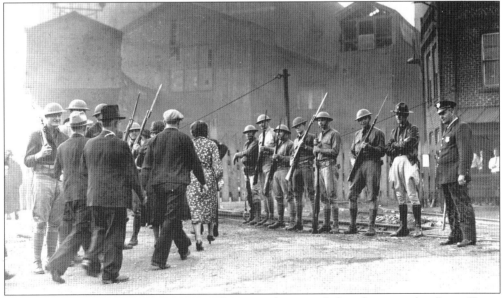

Several Republic workers march past a line up of National Guardsmen and police officers. (Cleveland Press Archives—CSU Library Special Collections.)

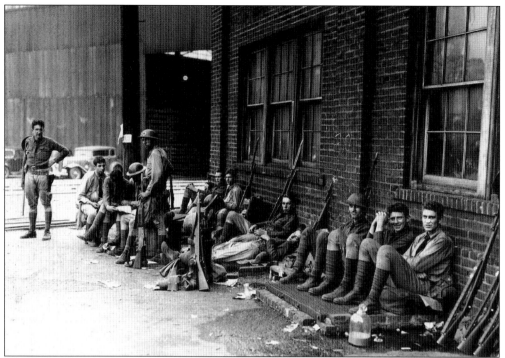

A group of Guardsmen take a moment to relax during the Little Steel Strike. (Cleveland Press Archives—CSU Library Special Collections.)

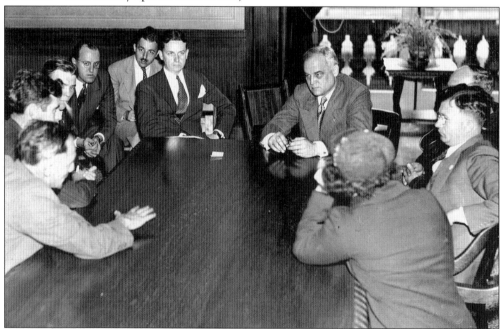

With workers marching onto Cleveland's Public Square, city officials were compelled to listen to the grievances of Republic Steel's labor force. At the head of the table, on the left, wearing the dark suit coat is Cleveland's safety director, Eliot Ness. On the right is Mayor Harold Burton. (Cleveland Press Archives—CSU Library Special Collections.)

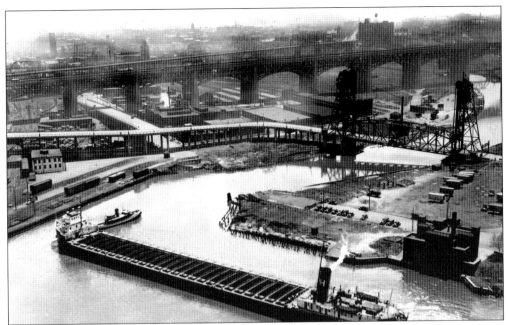

A steamer belonging to the Hutchinson fleet begins its turn (with able assistance from a Great Lakes tug boat) around the infamous Collision Bend. The bend would be widened somewhat after World War II, but it still presents a challenge to vessels today that are navigating the Cuyahoga. (Cleveland Press Archives—CSU Library Special Collections.)

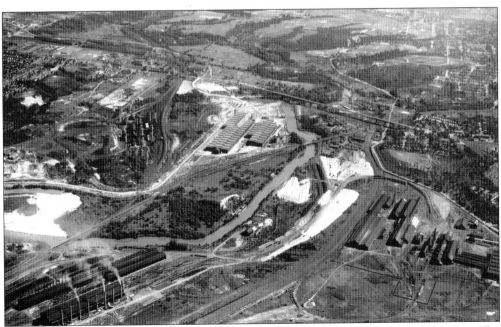

This 1938 aerial view presents the southern limit of what is generally considered the Flats. The cluster of buildings near the center is Republic Steel's strip mill. The bridge above and to the right of the strip mill is the Harvard/Denison Bridge, one of Cleveland's links between its east and west sides. (Cleveland Press Archives—CSU Library Special Collections.)

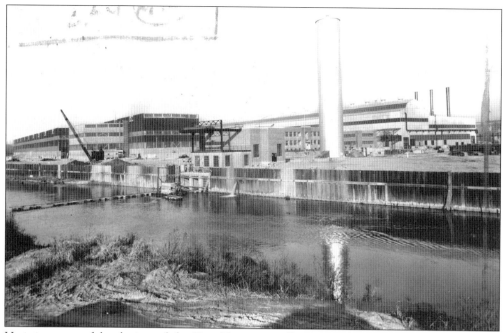

Here is a ground level view of the Republic strip mill seen in the previous image. This site alone would eventually occupy 182 acres along the Cuyahoga. (Cleveland Press Archives—CSU Library Special Collections.)

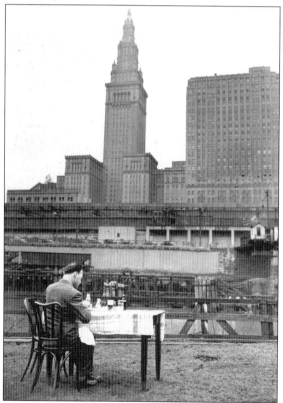

For over 50 years, Jim's Steakhouse would be a fixture along Collision Bend. Generations of Clevelanders enjoyed fine food in a classy art-deco setting. Some patrons, however, would take advantage of the al fresco option and enjoy the view of the Terminal Tower complex from outdoors. (Cleveland Press Archives—CSU Library Special Collections.)

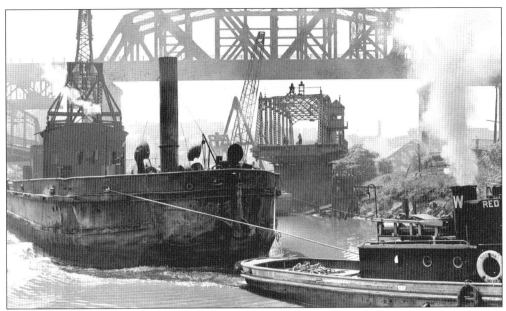

The tug *Red Crown* pulls a construction barge as the Columbus Street twin swing bridges are opened for repairs in the summer of 1938. Seen here working for the L. A. Wells Construction Company (hence the "W" on its stack), the *Red Crown* was actually built for the Standard Oil Company in 1923. The erstwhile tug would go through several more ownership changes and would be renamed *Canadian Mist* in 1976. (Cleveland Press Archives—CSU Library Special Collections.)

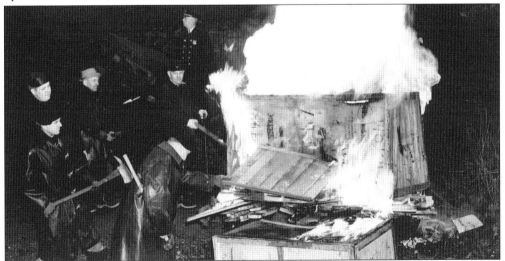

In September 1935, a dismembered human body was discovered along Kingsbury Run, a creek bed that leads into the Cuyahoga. By 1938, 11 more turned up, apparently all victims of the same "Torso Murderer". In 1939, with the murderer still on the loose, Cleveland's safety director, Eliot Ness, felt it necessary to destroy the city's shanty towns, lest they serve as a refuge for the mad man behind these ghastly crimes. Fire was set to the structures and the man-made "caves" that ran beneath them were carefully inspected. The murderer was never found, however, and the cases remain unsolved. (Cleveland Press Archives—CSU Library Special Collections.)

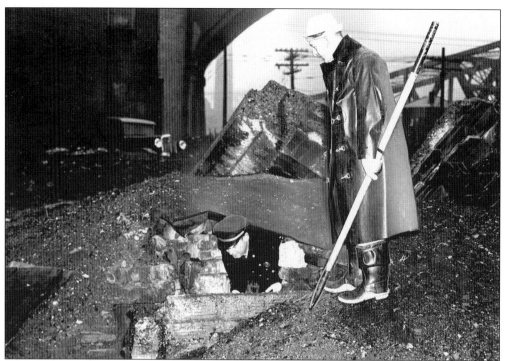

Police captain A. B. Nestor and Edward Bunasky inspect the charred remains of a homeless person's shelter for any evidence relating to the Torso Murderer. (Cleveland Press Archives—CSU Library Special Collections.)

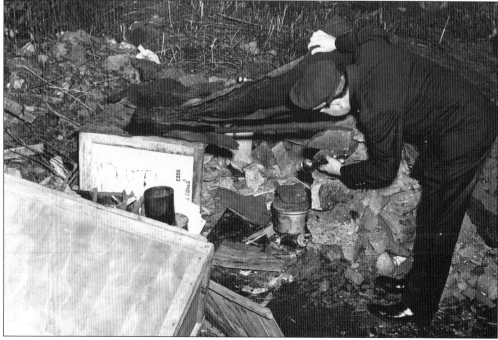

An unidentified Cleveland police officer carefully examines a burned-down shanty for clues. (Cleveland Press Archives—CSU Library Special Collections.)

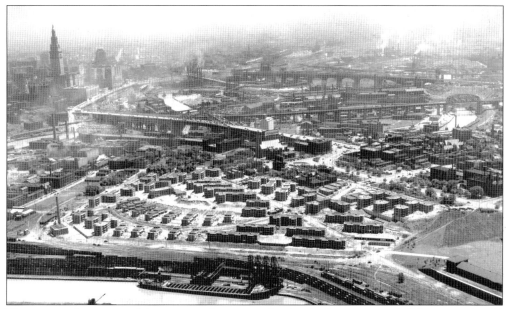

The area in the center of this image is known as the Angle. Located on a hill between the old channel of the Cuyahoga to the north and Detroit Avenue to the south, the Angle was home to many Irish immigrants beginning in the 1860s. The Irish who lived in this area were particularly proud of their heritage and were known for their clannishness. By the second decade of the 1900s, a large number of the Irish had started to move to other areas of the city. In the late 1930s, when this photograph was taken, the city had an acute need for low-cost housing. Thus modern apartment buildings, built with assistance from the Public Works Administration, rose where the ramshackle homes of the Angle Irish once stood. (Cleveland Press Archives—CSU Library Special Collections.)

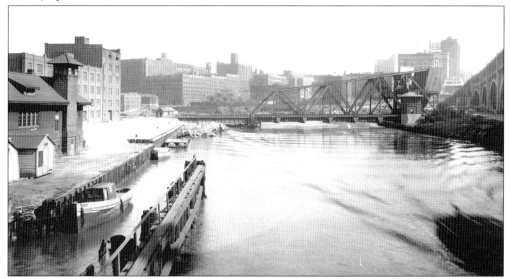

Maintaining infrastructure has always been a costly proposition. In 1940, when this image was taken, the estimated cost to replace the Baltimore and Ohio Railroad Bridge spanning the river was nearly $1 million. This bridge was eventually removed and replaced by a new jackknife bridge in 1956. (Cleveland Press Archives—CSU Library Special Collections.)

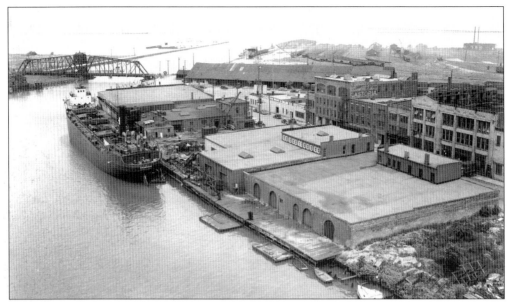

The steamer *Tristan* rests near the mouth of the Cuyahoga. Built in 1911, *Tristan* had already seen a good part of the world as it had sailed for interests in Uruguay, France, and Great Britain as well as the United States. The ship met its end in 1956 under the name *Lepus* while sailing for Madrigal Shipping Company Incorporated of the Philippines. Sunk by typhoon Jean, 25 of the ship's 36 crew members perished. (*William G. Mather* Collection—CSU Library Special Collections.)

The large chunk of rough-looking land in this image no longer exists as it was removed to clear space for vessels turning at Collision Bend. The Eagle Street Bridge still stands, although it has been kept in its raised position for some years now as the ramp leading up to it is in disrepair. Fire Station 21 (the brick structure with the tall chimney) is the home to the *Anthony J. Cellebrezze*, Cleveland's fire boat. And while Jim's Steakhouse closed for business 10 years ago, the building it occupied remains. (Cleveland Press Archives—CSU Library Special Collections.)

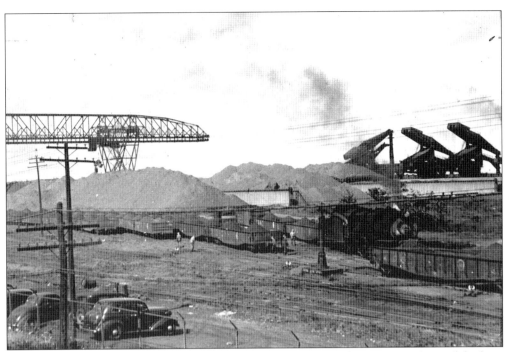

This 1941 view shows Huletts at work on Whiskey Island unloading iron ore from a lake boat while rail cars are gathered to transport the ore, most likely to mills along the Ohio River valley. (Cleveland Press Archives—CSU Library Special Collections.)

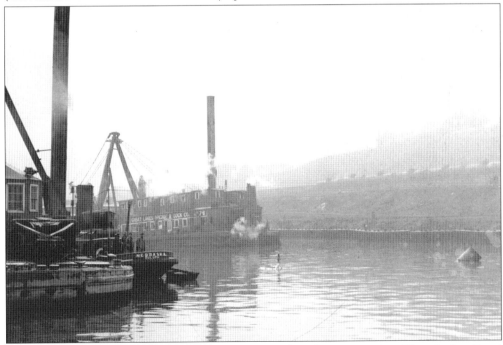

A sunken tug such as the one seen here was a serious obstacle to navigation. Thus dredges 7 and 55 from the Great Lakes Dredge and Dock Company have been called in to raise the tug out of the river. (Cleveland Press Archives—CSU Library Special Collections.)

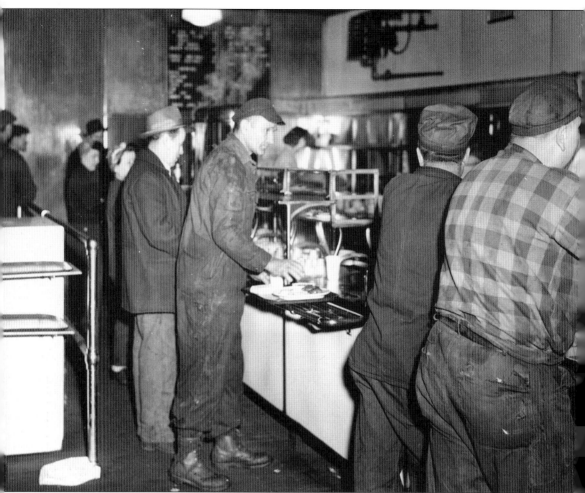

The Congress of Industrial Oranizations had been recognized by Republic Steel in 1942, three years before this photograph was taken. A group of now-unionized workers (including war-time female employees) take their lunch in the cafeteria of the Corrigan-McKinney works. (Cleveland Press Archives—CSU Library Special Collections.)

Two

1946–1959

POST–WORLD WAR II PROSPERITY

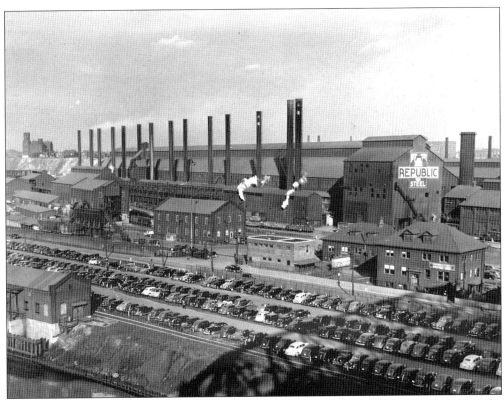

In the wake of World War II, Cleveland's economy was booming. The full parking lot here at the Corrigan-McKinney works of Republic Steel gives an indication of just how many people enjoyed good-paying industrial jobs. (Cleveland Press Archives—CSU Library Special Collections.)

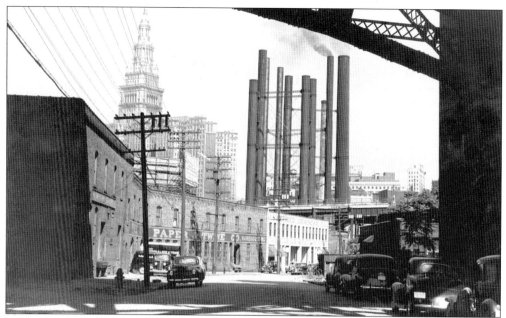

In the summer of 1946 this imaged was captured from beneath the Lorain-Carnegie Bridge, looking towards the north. Girders, stacks, and bricks often come together to form vistas such as this in the Flats. This image is also representative of the eclectic mix of businesses found in the region—a person would be hard pressed to find a paper and twine works located next door to a liquor wholesaler anywhere else in the city. (Cleveland Press Archives—CSU Library Special Collections.)

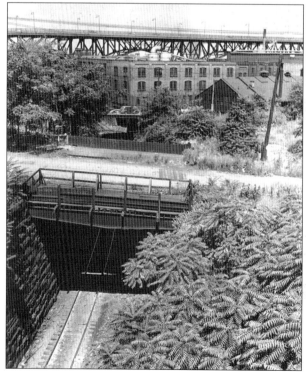

Although most of the Flats region is a landscape of man-made structures, mother nature does creep in from time to time. Often it is an attempt to reclaim her territory as in this view looking toward the Main Avenue Bridge. (Cleveland Press Archives—CSU Library Special Collections.)

Sherwin-Williams, like Republic Steel, would be quite prosperous in the years immediately after World War II. This solvent extraction plant was built in 1947 at a cost of $750,000. (Cleveland Press Archives—CSU Library Special Collections.)

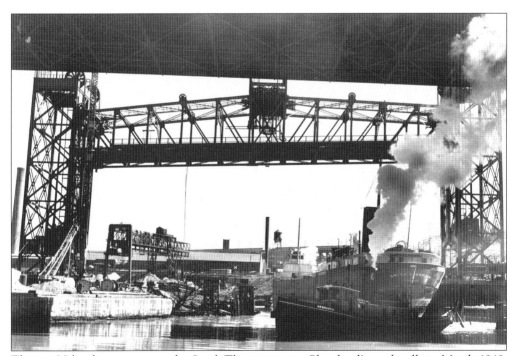

The tug *Nebraska* steams past the *Smith Thompson* near Cleveland's steel mills in March 1948. The *Smtih Thompson* was built in 1907 and is seen here working for the Great Lakes Steamship Company. Like many steamboats of its size and age, the *Smith Thompson* was towed to Europe for scrapping in the early 1960s. (Cleveland Press Archives—CSU Library Special Collections.)

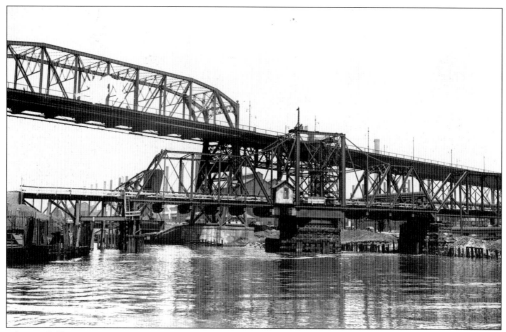

Three different varieties of bridges can be found in this image. The Wheeling and Lake Erie Railroad swing bridge comes first, followed by the Clark Avenue Bridge. Just on the other side of Clark Avenue is the River Terminal Railway Bridge, which connected Republic Steel's operations on both sides of the Cuyahoga. (Cleveland Press Archives—CSU Library Special Collections.)

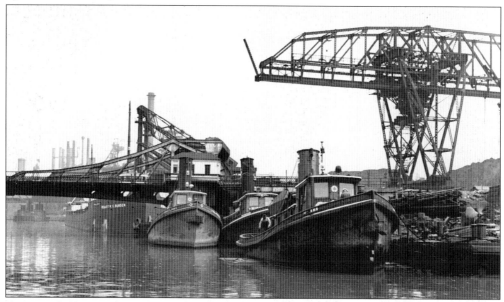

A trio of Great Lakes Towing Company tug boats almost appears to be guarding the 439-foot-long *Robert W. E. Bunsen* as it is unloaded by Huletts. The *Bunsen* was built in 1900 and worked for the United States Steel fleet for over 50 years. It spent its last days before scrapping in 1973 as a grain storage boat in New Orleans. (Cleveland Press Archives—CSU Library Special Collections.)

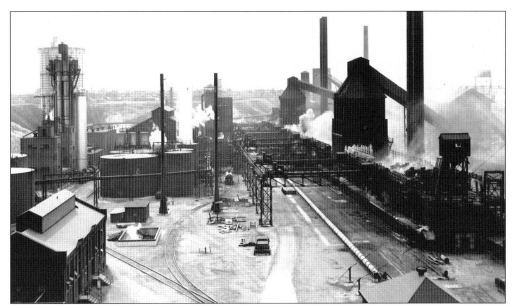

Clevelanders who grew up near the Flats became accustomed to the billows of industrial smoke that emanated from the valley below. While all of the discharge coming from Republic Steel's stacks made drying clothes outdoors difficult, most folks were willing to put up with sooty linens if it meant they and their neighbors were employed. (Cleveland Press Archives—CSU Library Special Collections.)

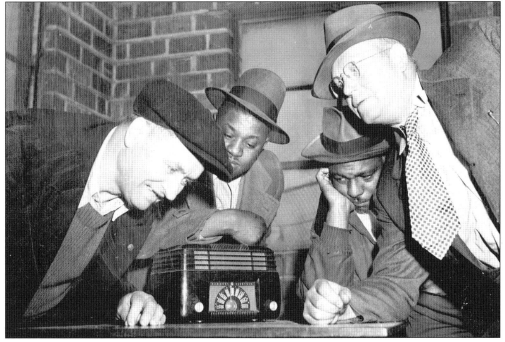

Strikes were a rather frequent occurrence at Republic Steel throughout the late 1940s and 1950s. None would reach the proportions of the 1937 strike, however, as disputes would be resolved without bloodshed. This group of Republic Steel strikers is eagerly listening to the radio for any news regarding their situation. (Cleveland Press Archives—CSU Library Special Collections.)

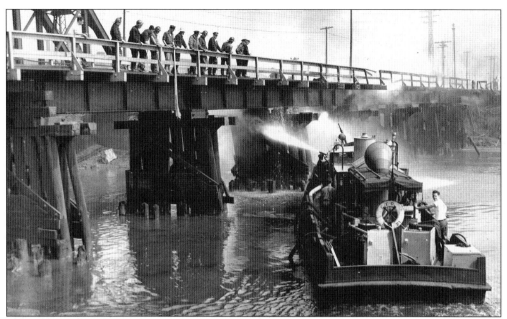

Unfortunately, strikes have not been the only regular event in the Flats. The Cuyahoga erupting into flame was also a somewhat commonplace situation throughout the 20th century. Oil and other chemicals would coagulate on the river's surface, waiting for a stray spark or carelessly dispatched cigarette to ignite a blaze. Although a fire in 1969 would capture the attention of the nation, this particular blaze was photographed 20 years earlier. (Cleveland Press Archives—CSU Library Special Collections.)

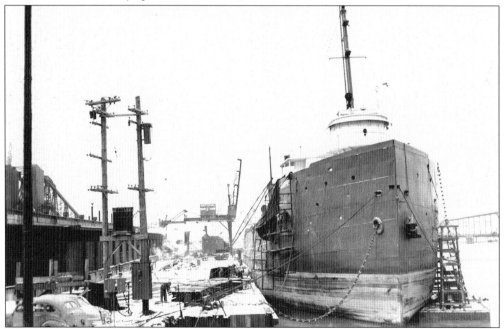

Workers tend to the steamer *Simon J. Murphy* in February 1950. The 435-foot-long *Murphy* would work for another 10 years after this image was taken before being scrapped on the old river bed of the Cuyahoga. (Cleveland Press Archives—CSU Library Special Collections.)

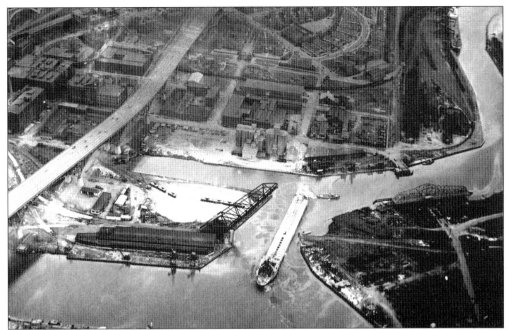

The laws of physics are again blatantly ignored as this lake boat maneuvers into the old channel of the Cuyahoga in the spring of 1950. (Cleveland Press Archives—CSU Library Special Collections.)

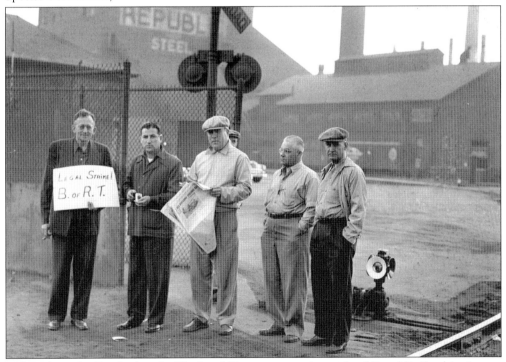

Pickets from the Brotherhood of Railroad Trainmen stand outside of Republic Steel in August 1950. Also, the eagle-eyed reader will note the headline on the one gentleman's *Plain Dealer* regarding events in Korea. (Cleveland Press Archives—CSU Library Special Collections.)

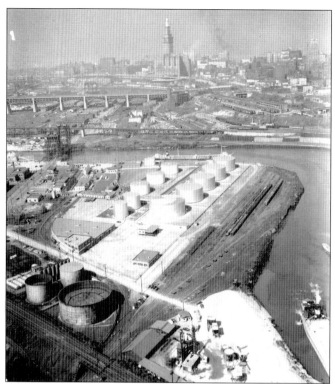

Standard Oil was not alone in the Flats as the Texas Company (Texaco) also had operations along the Cuyahoga. To the lower left in this image is a gasoline storage tank. The top of the tank is actually floating atop the gasoline inside. If the tank had a conventional cover, fumes could accumulate inside increasing the risk for a catastrophic explosion. (Cleveland Press Archives—CSU Library Special Collections.)

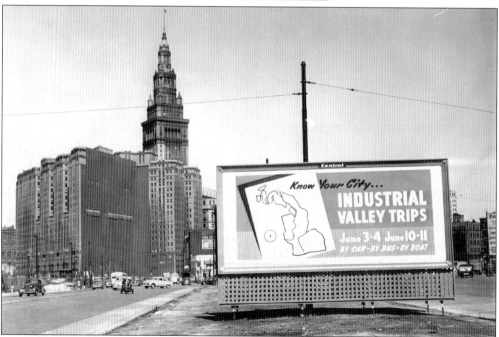

The *Cleveland Press* sponsored a number of Industrial Valley Trips in the 1950s. People taking the tours could drive themselves by following tour markers and instructions printed in the *Cleveland Press*, board buses, or float along the Cuyahoga in excursion boats. (Cleveland Press Archives—CSU Library Special Collections.)

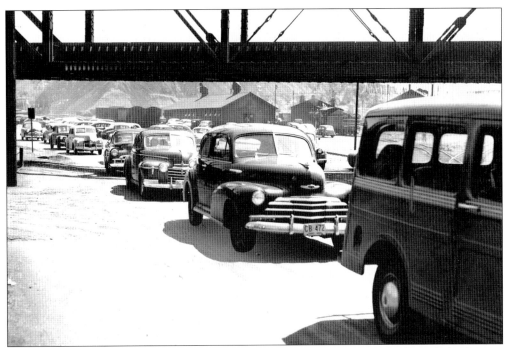

A group of cars departs the Terminal Railway repair shop under the Clark Avenue Bridge at the start of an Industrial Valley Trip. (Cleveland Press Archives—CSU Library Special Collections.)

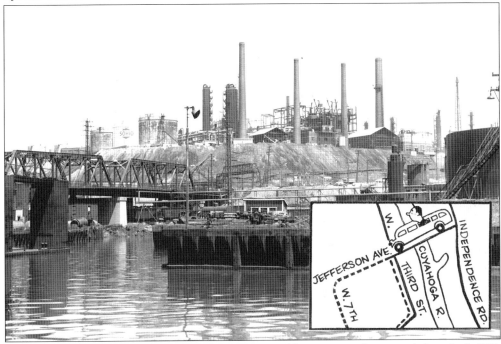

Tourists following the Industrial Valley route could get a good view of Standard Oil's refinery located near West Third Street. (Cleveland Press Archives—CSU Library Special Collections.)

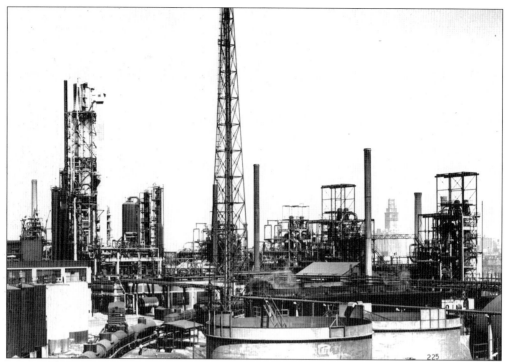

Pictured here is another view of Standard's Cleveland works as they appeared in 1951. One can barely see the Terminal Tower to the right through the mass of derricks, pipes, and tanks. (Cleveland Press Archives—CSU Library Special Collections.)

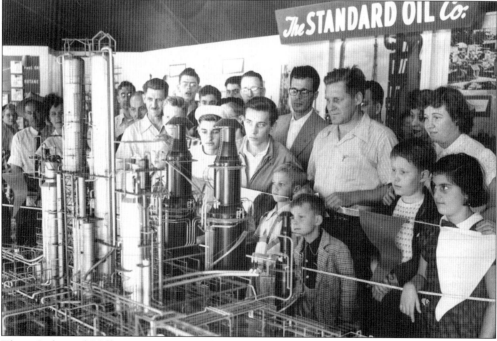

These Industrial Valley tourists are studying a model of Standard Oil's number one refinery. (Cleveland Press Archives—CSU Library Special Collections.)

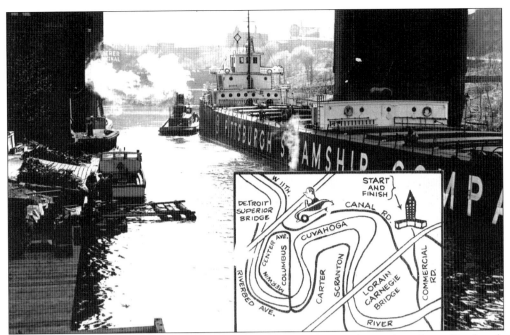

The Industrial Valley Trips would also give folks a chance to see sights such as this, a Pittsburgh Steamship Company (the U.S. Steel Company's shipping fleet) boat navigating beneath the Detroit-Superior Bridge. At one point, PSC had over 100 vessels. Several of them had structures mid-ship, such as the one on this boat. This small deckhouse would serve as an extra dining room if any guests should be aboard. (Cleveland Press Archives—CSU Library Special Collections.)

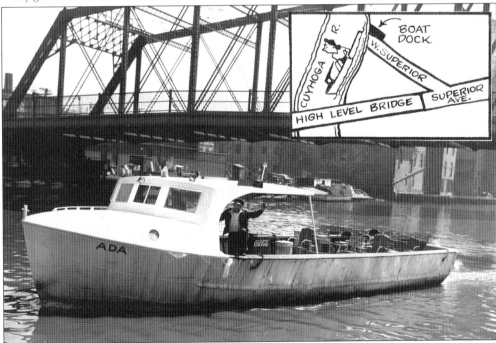

Capt. Johnny Skrovan waves for the camera as he prepares to take on Industrial Valley sightseers aboard his boat *Ada*. (Cleveland Press Archives—CSU Library Special Collections.)

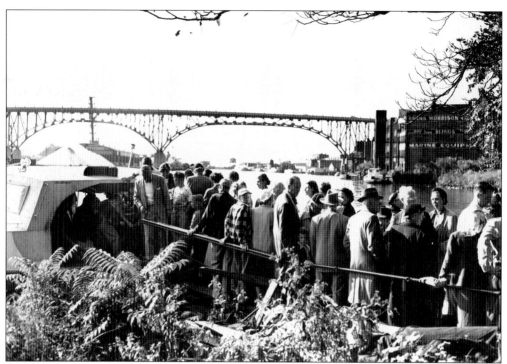

Passengers line up on the east bank of the Flats to board *Ada*. (Cleveland Press Archives—CSU Library Special Collections.)

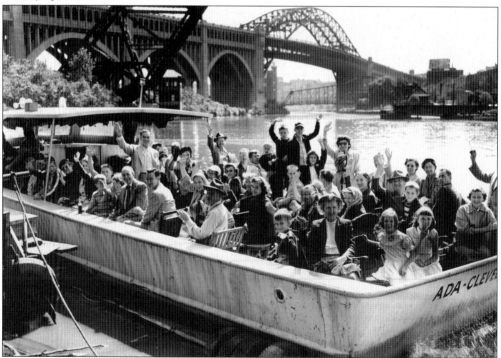

A capacity crowd fills *Ada* for a tour of the Cuyahoga. (Cleveland Press Archives—CSU Library Special Collections.)

A set of Huletts are at work in the holds of the 504-foot-long *William H. Wolf*. The 10,000 tons of iron ore that the *Wolf* took on at Escanaba, Michigan, was loaded into Nickel Plate Railroad cars bound for Massilon, Ohio. (Cleveland Press Archives—CSU Library Special Collections.)

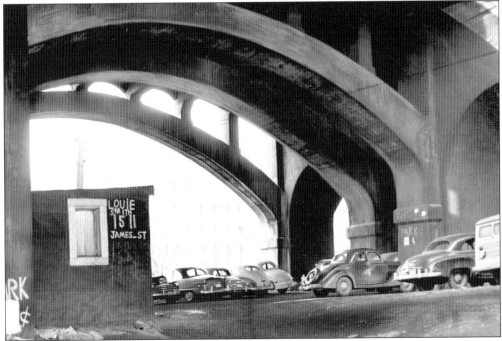

Park at Louie's! Located underneath the Detroit-Superior Bridge, Louie Smith's parking lot afforded automobiles some shelter from the elements. (Cleveland Press Archives—CSU Library Special Collections.)

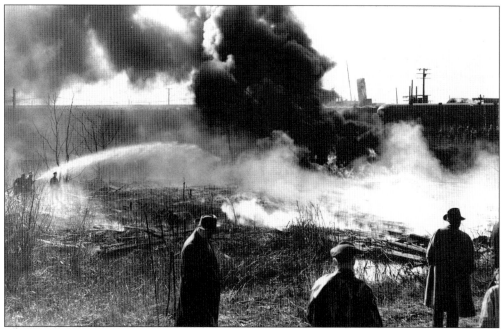

Firemen work to extinguish another blaze along the Cuyahoga in this 1951 image. (Cleveland Press Archives—CSU Library Special Collections.)

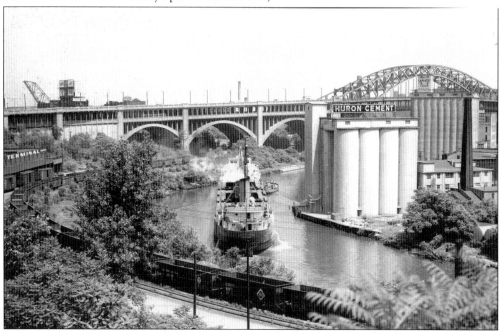

Huron Cement once had a cement dock at the Irish Town Bend. As the *Clifford Hood* demonstrates, however, the site that Huron's facilities occupied made navigation somewhat more challenging. And, at 421 feet long and 50 feet wide, the *Hood* was actually among the smaller ships working when this image was taken in 1952 so one can imagine the trouble larger boats had. Cleveland voters would approve a $2 million issue to move Huron to another location and then widen the river. (Cleveland Press Archives—CSU Library Special Collections.)

Labor troubles would again plague Republic Steel in May 1952. A group of striking workers met while the last man out of the Bolt and Nut Division tipped his hat. (Cleveland Press Archives—CSU Library Special Collections.)

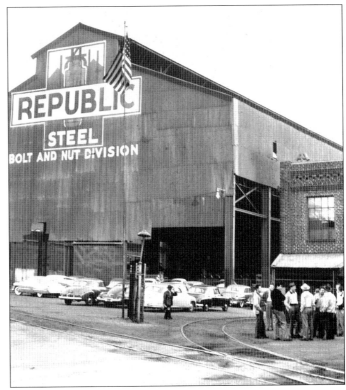

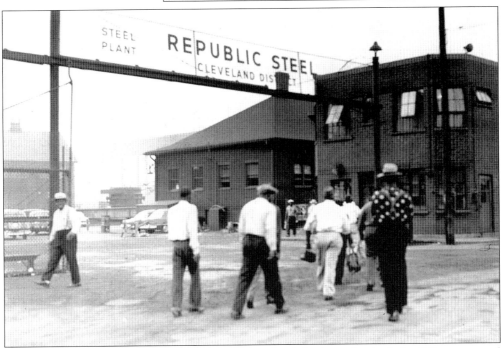

By July 1952, the steelworkers and Republic Steel had resolved their differences and employees would again filter through the gates. (Cleveland Press Archives—CSU Library Special Collections.)

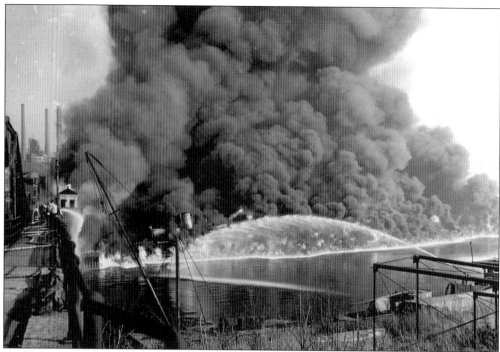

The Cuyahoga caught fire again in late 1952, this time near Jefferson and West Third Streets. Firefighters struggle against the flames and thick smoke while a Great Lakes tug boat lies helpless in the water. (Cleveland Press Archives—CSU Library Special Collections.)

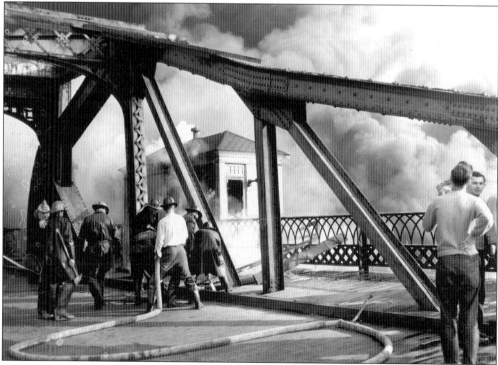

Picture here is another view of the 1952 Cuyahoga River fire.

Cleveland's fireboat moored next to Fire Station No. 21.

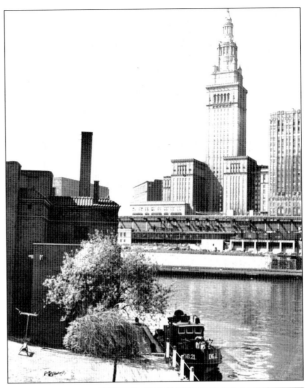

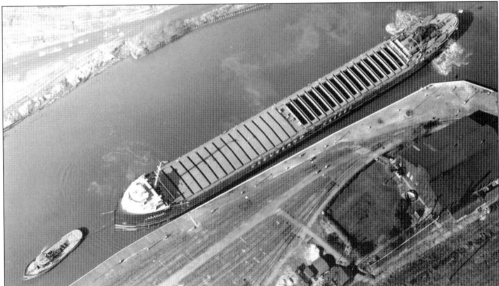

For nearly 100 years, the Cleveland-Cliffs Iron Company had its own fleet of boats to carry iron ore from ports such as Marquette, Michigan, to Cleveland. One of these boats was the steamer *La Salle*, a 550-foot-long vessel that had been built in 1906 and was originally named the *J. H. Sheadle*. By 1953, when this photograph was taken, the *La Salle* had many a sea story to tell, including the tale of the infamous 1913 "White Hurricane." While the former *Sheadle* and its crew got through the tempest, over 200 sailors perished in what was perhaps the worst storm in Great Lakes' history. (Cleveland Press Archives—CSU Library Special Collections.)

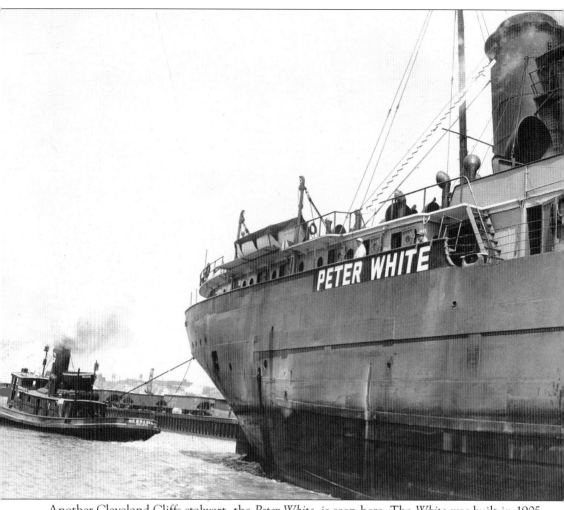

Another Cleveland-Cliffs stalwart, the *Peter White*, is seen here. The *White* was built in 1905, measured in at 524 feet long, could carry 9,000 tons of cargo, and served in the Cleveland-Cliffs's fleet until 1959. (Cleveland Press Archives—CSU Library Special Collections.)

Winter takes hold along the Cuyahoga in 1954. The boat in lay-up near the bottom of the photograph is an early self-unloader, as evidenced by the discharge boom over its spar deck. (Cleveland Press Archives—CSU Library Special Collections.)

A collection of boats is laid up along the old river bed of the Cuyahoga. Before the mid-19th century, this section had been the mouth of the river. Deemed an impediment to navigation, the old flow would be by-passed and a new much wider and straighter mouth was cut. (Cleveland Press Archives—CSU Library Special Collections.)

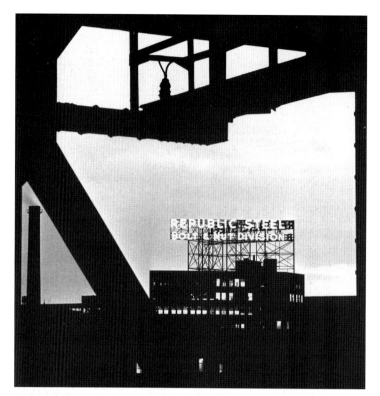

The large illuminated sign of Republic Steel's Bolt and Nut Division stands proudly over the Flats on a summer evening in 1954. (Cleveland Press Archives—CSU Library Special Collections.)

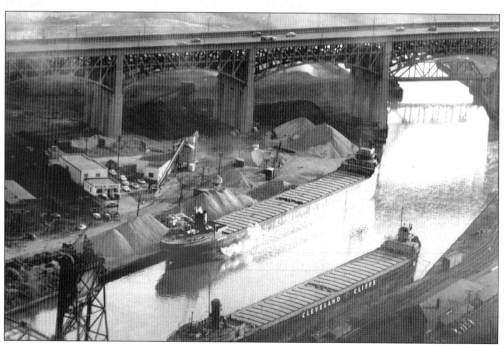

As cars travel over the Lorain-Carnegie Bridge, the Cleveland-Cliffs steamers *Peter White* and *Ishpeming* hibernate during the winter of 1955–1956. (Cleveland Press Archives—CSU Library Special Collections.)

Some of the tools of the refining trade are seen in SOHIOs Cleveland works in 1955. Thermal cracking plants to the left share space with the gas plants on the right and the Horton spheroids, which were used to store butane gas, at the rear. (Cleveland Press Archives—CSU Library Special Collections.)

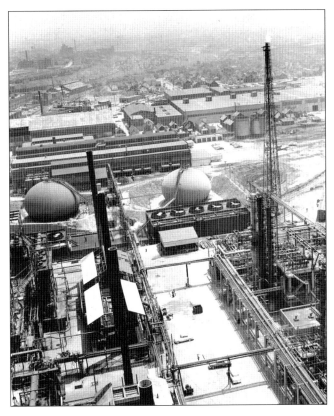

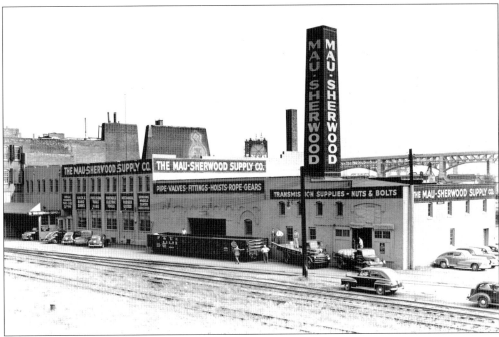

The Mau-Sherwood Supply Company could be counted on to provide items ranging from hack saws to rope. (Cleveland Press Archives—CSU Library Special Collections.)

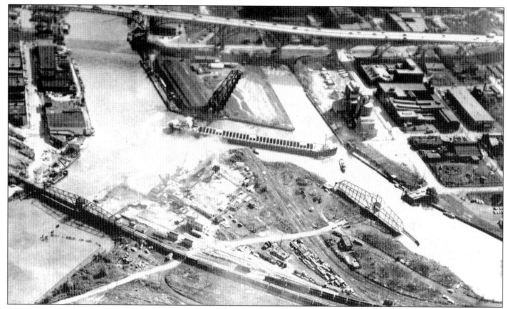

The bridges are at work while a freighter attempts to enter the old bed of the Cuyahoga. Spanning the mouth of the river is a swing bridge that served the New York Central and Pennsylvania Railroads. The raised trestle worked for the Baltimore and Ohio Railroad and the open swing bridge connected Willow Street to the west bank of the Flats. The Willow Street and New York Central and Pennsylvania Bridges would both be replaced. The Baltimore and Ohio trestle remains, but is locked in its raised position. (Cleveland Press Archives—CSU Library Special Collections.)

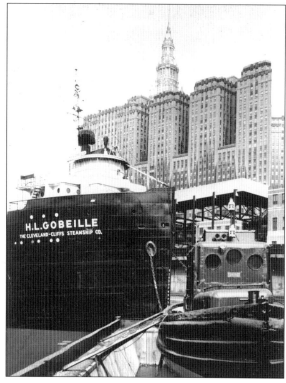

Some people involved in the maritime trade feel it is bad luck to rename a ship. Cleveland-Cliffs felt no such qualms, however, and would regularly rename its vessels. Among them were the *H. L. Gobeille*, which started its life as the *William G. Mather*. It was renamed the *J. H. Sheadle* (the second Cliffs boat to carry that moniker) in 1925 when Cliffs built a new *Mather* to serve as the fleet's flagship. The 533-foot-long ship wound up as the *Gobeille* in 1955. Cliffs sold the boat in 1963 and it soldiered on under the name *Nicolet* until it was scrapped in 1996. (Cleveland Press Archives—CSU Library Special Collections.)

60

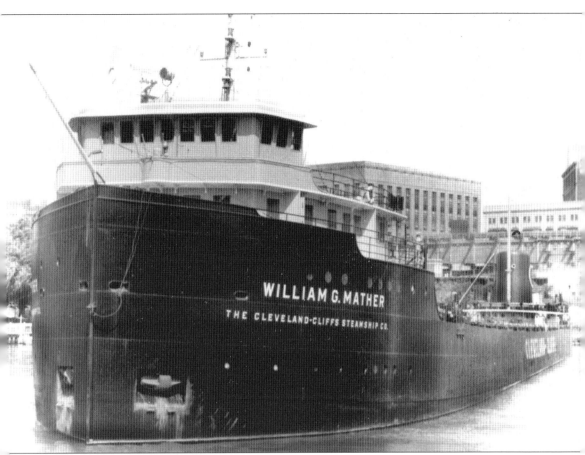

The second steamship to carry the name *William G. Mather* navigates Collision Bend. Unlike its predecessor, this *Mather* would keep its name throughout its entire career from 1925 until 1980. Although the ship lost its flagship status in 1952, it was still a viable member of the Cleveland-Cliffs fleet and was updated with new equipment, such as a new power plant (1954), a boiler automation computer, and a bow thruster (both in 1964). The *Mather* is now a museum ship moored behind the Great Lakes Science Center in Cleveland. (*William G. Mather* Collection—CSU Library Special Collections.)

Completed in 1959, the Innerbelt Project would connect two major interstates (I-71 and I-90) to Cleveland's downtown. This 1956 image is of the northern end of the Innerbelt Bridge over the Flats as it was being built. (Cleveland Press Archives—CSU Library Special Collections.)

Pictured here is the southern portion of the recently finished Innerbelt Bridge. (Cleveland Press Archives—CSU Library Special Collections.)

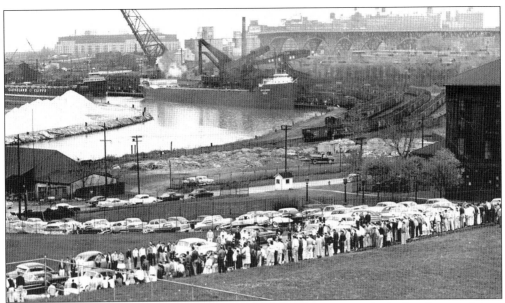

The hot rod set has long gathered in various parts of the Flats to not only display their machines, but to race them as well. A large group of car enthusiasts has gathered on a Sunday afternoon in this photograph taken in the spring of 1957. No matter how powerful these automobiles are, however, none can match the horsepower of a lake boat like SS *Frontenac*, seen with the Cleveland-Cliffs moniker on its hull. The *Frontenac*'s steam turbine engine could produce 5,000 horses. (Cleveland Press Archives—CSU Library Special Collections.)

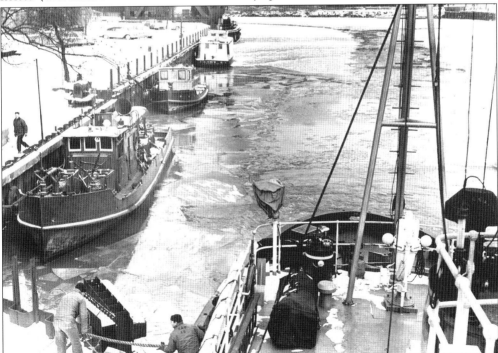

Crews fight to break apart ice on the Cuyahoga in February 1958. (Photograph by John Nash, Cleveland Press Archives—CSU Library Special Collections.)

Clouds hang in the sky as the viewer looks east along the old bed of the Cuyahoga in this 1958 image. (Cleveland Press Archives—CSU Library Special Collections.)

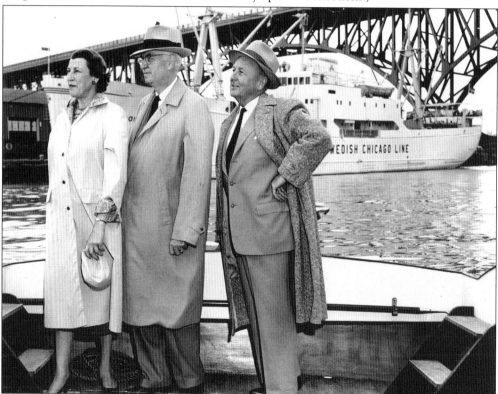

As the St. Lawrence Seaway Project neared its completion, the city of Cleveland attempted to improve its port facilities and navigation along the Cuyahoga. Taking a tour of the recently modified river are Cleveland's customs collector Albina Cermark (left), Sen. John W. Bricker (center), and city port director W. J. Rogers. (Cleveland Press Archives—CSU Library Special Collections.)

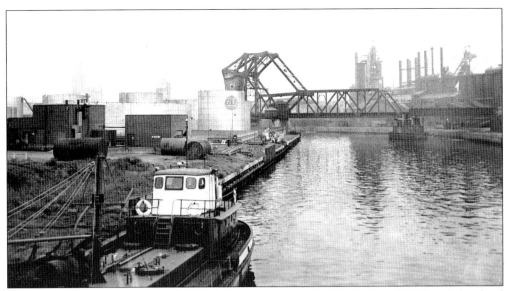

Straddling the Cuyahoga near the head of navigation is the Erie Railroad Bridge. (Cleveland Press Archives—CSU Library Special Collections.)

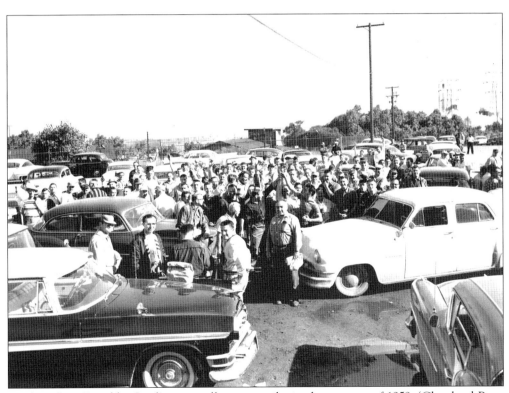

Workers from Republic Steel's strip mill are on strike in the summer of 1959. (Cleveland Press Archives—CSU Library Special Collections.)

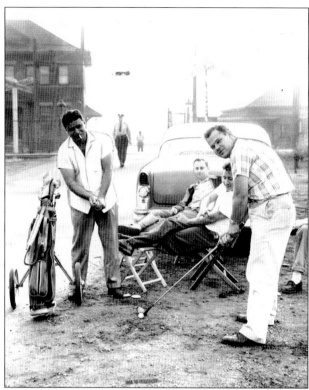

These men work on their golf swings while manning the picket line during the 1959 Republic Steel strike. (Photograph by Bernie Noble, Cleveland Press Archives—CSU Library Special Collections.)

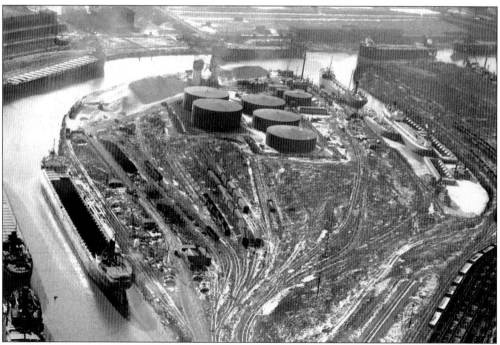

Here is a winter lay-up along the old flow of the Cuyahoga. Note the unique boat in the inlet to the right of the image. That particular vessel is the *Meteor*, the last whaleback to sail the Great Lakes. (Cleveland Press Archives—CSU Library Special Collections.)

Three

1960–1979

DECLINE AND DETERIORATION

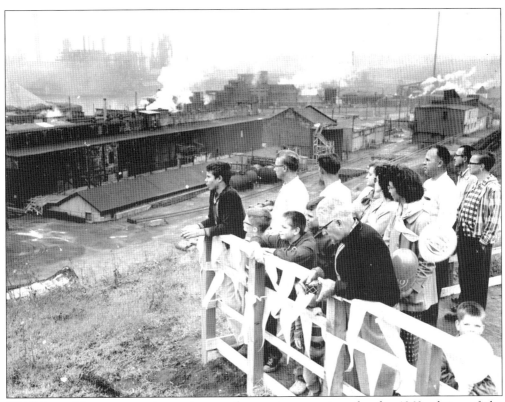

SOHIO would set up an observation porch over its operations for the 1960 edition of the Industrial Valley Tour. (Cleveland Press Archives—CSU Library Special Collections.)

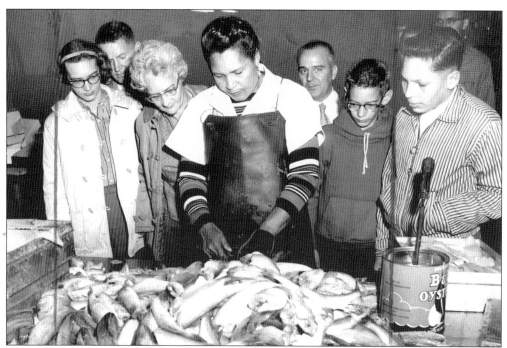

Travelers along the Industrial Valley Tour watch as an employee from the State Fish Company prepares a fresh catch for sale. The State Fish Company was founded in 1933, and it grew into the Cleveland area's top seafood wholesaler. (Cleveland Press Archives—CSU Library Special Collections.)

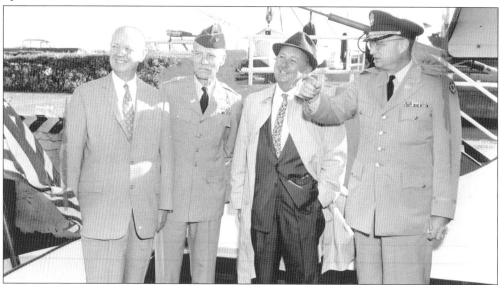

Although Cleveland lagged behind other Great Lakes's ports in its St. Lawrence Seaway–related improvements, $25 million was spent on replacing old bridges and improving navigation on the Cuyahoga. Inspecting the results of this project in September 1960 are (from left to right) O. A. Reynolds from Cleveland's chamber of commerce, Gen. Thomas D. Rogers of the U.S. Army Corps of Engineers, port director W. J. Rogers, and Col. Earle B. Butler, also from the Army Corps of Engineers. (Cleveland Press Archives—CSU Library Special Collections.)

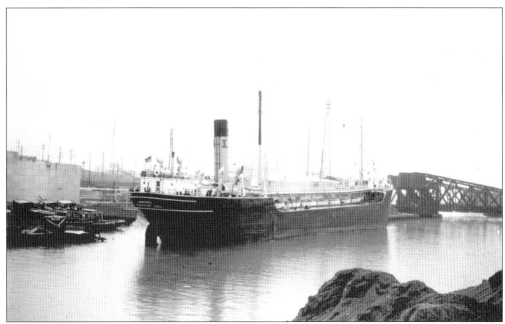

The oil tanker *Rocket* was built in 1913 as the *Radiant* for the Standard Oil Company. Acquired by Cleveland Tankers Incorporated in 1933, the 349-foot-long boat was towed to Spain in 1974 for scrapping. (Photograph by W. W. Vance; the Robert Vance Collection)

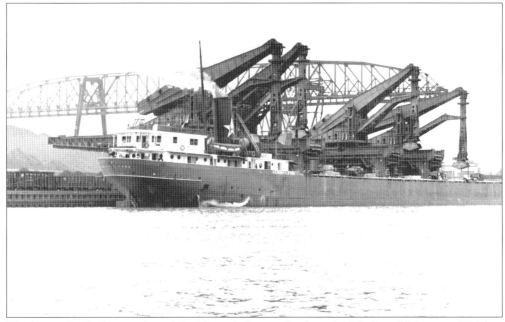

The *Emory L. Ford*, a member of the Hannah fleet, unloads at the lakefront Huletts on Whiskey Island. The *Ford* went through several owners and saw its name changed to *Raymond H. Reiss* before ending up with Cleveland-Cliffs. The boat was scrapped in 1981. (Cleveland Press Archives—CSU Library Special Collections.)

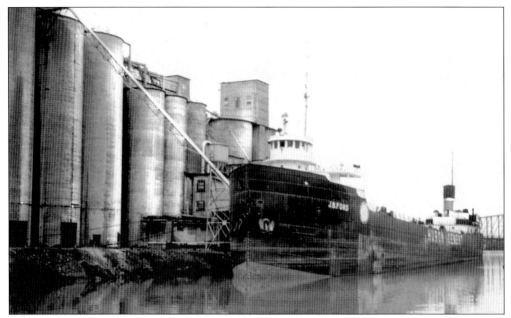

Another Ford, this time it is the *J. B. Ford*, which began its career in 1904 as the *Edwin F. Holmes*. When other ships of its size (420 feet long) and vintage began to be scrapped, the *Ford* found a comfortable niche in the cement trade where boats did not need to be large, new, or particularly fast. (Photograph by W. W. Vance; the Robert Vance Collection.)

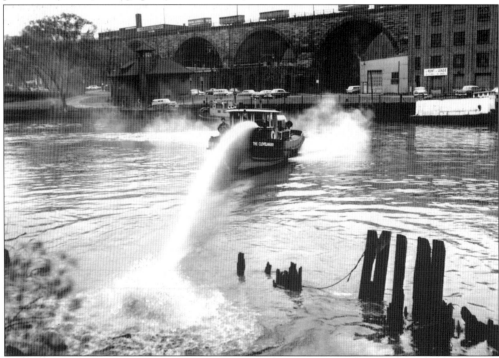

As noted earlier, fire was an ever-present threat along the Cuyahoga. Here the fireboat *Clevelander* attempts to prevent an oil blaze by breaking up a slick near the Superior Viaduct. (Cleveland Press Archives—CSU Library Special Collections.)

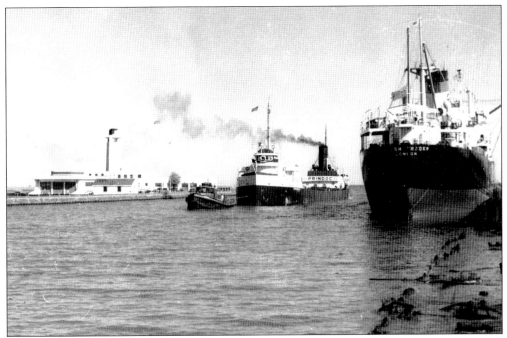

The early 1960s would see an increase in the number of ocean-going foreign vessels that visited Cleveland via the St. Lawrence Seaway. Among them was the *Welsh Trader*, seen in this image near the entrance to the Cuyahoga. The inbound lake boat is the *Prindoc*, a 387-foot-long boat that was built in 1902 as the *Harold B. Nye*. (Photograph by Joseph Ostendorff; the Robert Vance Collection.)

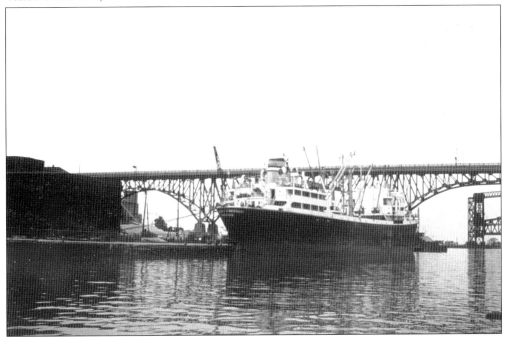

An Italian "salty," or ocean-going ship, is docked south of the Main Avenue Bridge in 1962. (Photograph by Robert Vance.)

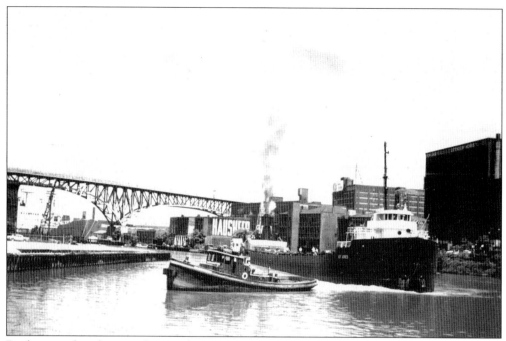

By the time this photograph was taken in 1962, the B. F. Jones (originally known as the *General Garretson*) had been sailing the lakes for 55 years. The 520-foot-long veteran of the Inland Seas did not survive indefinitely, however, as it was scrapped in Spain in the early 1970s. (Photograph by Robert Vance.)

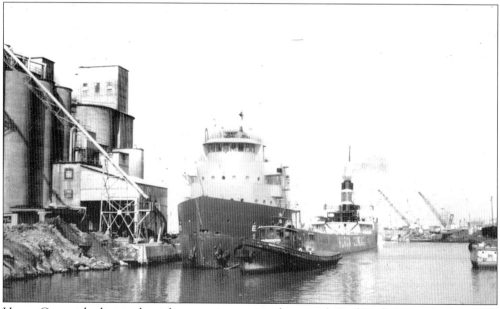

Huron Cement had a penchant for operating ancient boats with Ford in their names. Seen with the Great Lakes Towing Company tug *Washington* is the *E. M. Ford*. This particular *Ford* was built in 1898 and would remain in use into the 1980s. The crews in the background are busy dismantling the old Willow Street Bridge to make way for a new lift-bridge. (Photograph by Robert Vance.)

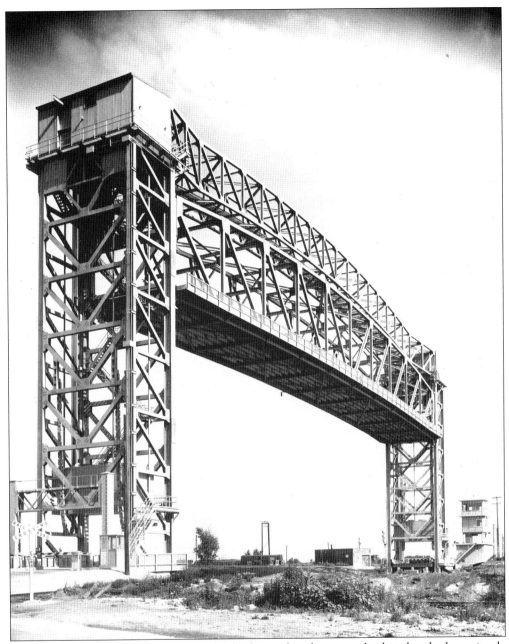

Finished in 1964, the Willow Street lift-bridge replaced a swing-bridge that had previously spanned the old river bed of the Cuyahoga. Spanning over 300 feet, the bridge is raised nearly 100 feet over the river's surface when vessels need to pass. (Cleveland Press Archives—CSU Library Special Collections.)

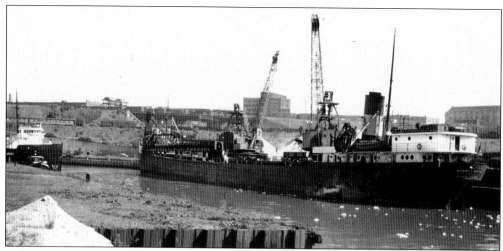

A summer's day in 1964 finds one of the Great Lakes' floating oddities moored at the Central Furnace dock. The *Robert C. Norton* began its life in 1910 as a conventional lake boat named the *Leonard B. Miller*. The boat was acquired by the Columbia Steamship Company in 1921 and then converted into a hybrid self-unloader/crane ship in 1958. While the *Norton* could discharge cargoes such as iron ore using conveyor belts, it could also load or unload scrap metal with its electro-magnet equipped cranes. (Photograph by Robert Vance.)

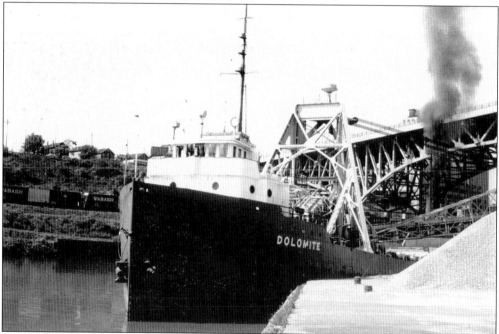

Unloading limestone near West Third Street is the *Dolomite*. Constructed in 1897 and originally named the *Empire City*, this boat was best known as the *Sumatra* from 1929 until 1962. It was as the *Sumatra* that the ship earned a well-deserved reputation as one of the worst on the lakes. Cramped quarters and suspect hull plates made the *Sumatra* a nightmare for its crews. The boat was so bad that its owners had difficulties finding men willing to sail aboard it. Very few tears were shed when it was scrapped in 1968. (Photograph by W. W. Vance; the Robert Vance Collection.)

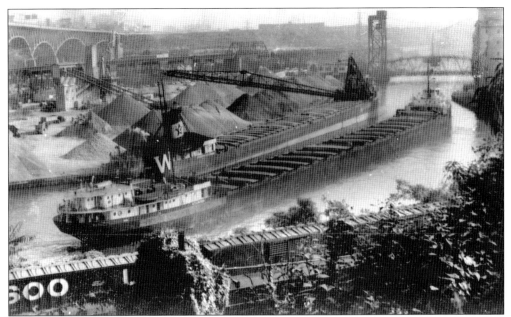

The Wilson Marine Transit Company's A. T. Lawson waits for the West Third Street lift-bridge to be raised while the Columbia Transportation Company's *Crispin Oglebay* unloads. The deck of the West Third Street Bridge was removed in 2005 and was rebuilt and reinstalled in early 2006. (Photograph by Joseph Ostendorff; the Robert Vance Collection.)

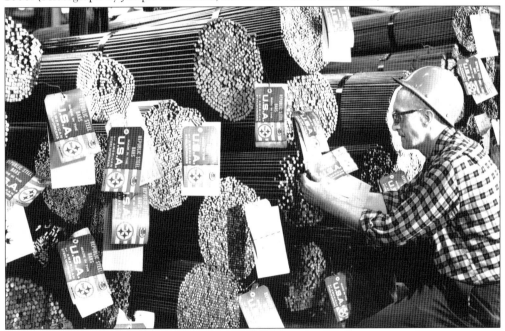

As early as 1964, competition from foreign steel makers was beginning to make an impact in the American steel market. One aspect of the response by domestic steel producers was to emphasize the quality of American-made steel products. As such, a worker from Republic Steel affixes "Made in the USA by American steelworkers" labels to a batch of freshly produced bars. (Cleveland Press Archives—CSU Library Special Collections.)

Jim's Steakhouse is shown here on a winter's day in 1964. (Photograph by Bill Nehez; Cleveland Press Archives—CSU Library Special Collections.)

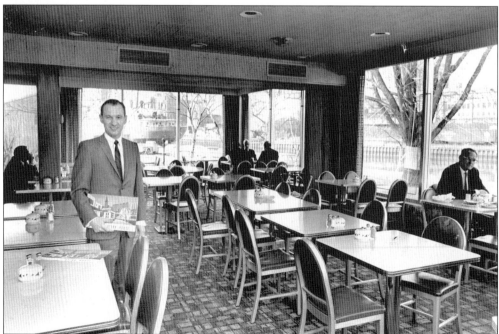

Inside Jim's Steakhouse, manager Raymond Rockey stands ready to attend to his lunch-time guests. (Photograph by Bill Nehez; Cleveland Press Archives—CSU Library Special Collections.)

Pollution in the Cuyahoga was a growing concern for Clevelanders in the 1960s. In this photograph, city councilmen Edward F. Katalinas, John Pilch, and Henry Sinkiwicz inspect waste from Jones and Laughlin Steel. (Cleveland Press Archives—CSU Library Special Collections.)

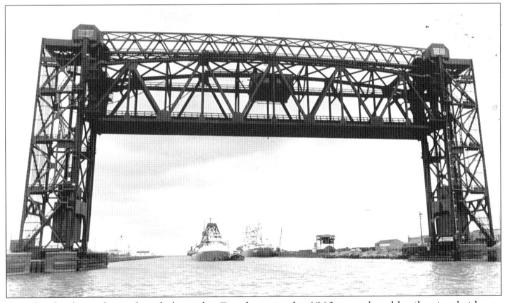

Another bridge to be replaced along the Cuyahoga in the 1960s was the old rail swing-bridge at the mouth of the river. The bridge's center-mount took up so much space that virtually half of the river was blocked. Plans for a new lift-bridge were drawn up in the late 1940s and the results are seen here. The trestle is raised in this image to allow vessel traffic to pass. (Photograph by Bernie Noble; Cleveland Press Archives—CSU Library Special Collections.)

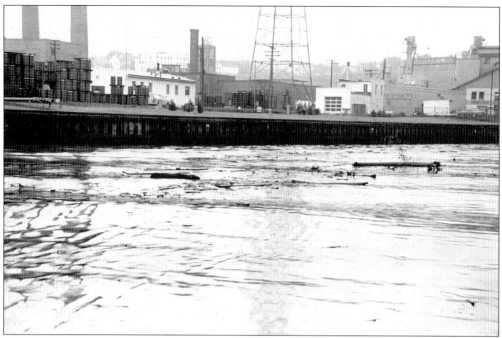

In August 1965, Cleveland played host to a Federal Pollution Conference. This image of waste from a summer storm was captured not long after the conference. (Cleveland Press Archives—CSU Library Special Collections.)

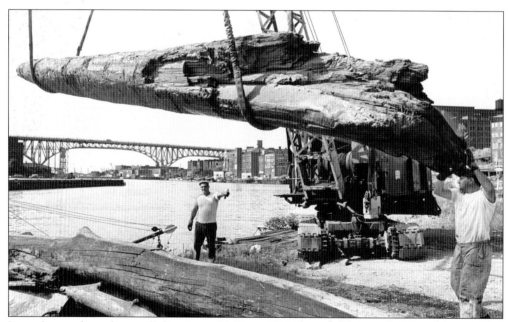

Large logs such as these will float into the Flats either from further up the Cuyahoga itself or from one of its several tributaries. No matter where they come from, however, logs of this size present a hazard to navigation and must be removed. (Cleveland Press Archives—CSU Library Special Collections.)

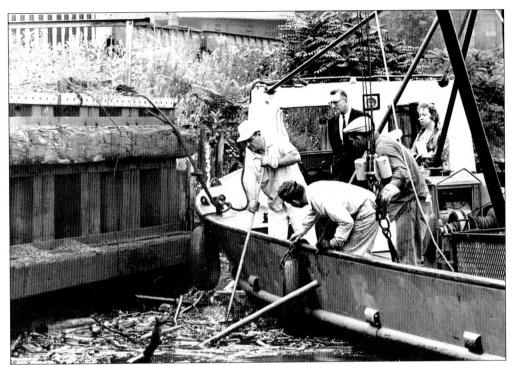

Workers dredge out and inspect a mass of waste matter along the Cuyahoga. (Photograph by Herman Seid; Cleveland Press Archives—CSU Library Special Collections.)

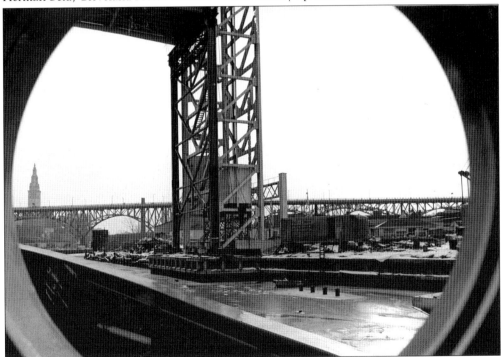

Here is a porthole perspective of an icy Cuyahoga during the winter of 1964–1965. (Photograph by Clayton Knipper; Cleveland Press Archives—CSU Library Special Collections.)

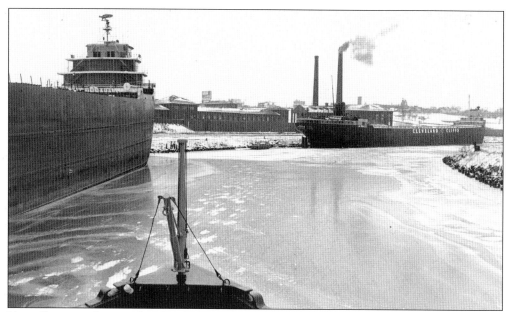

Virtually encased in ice, the Cleveland-Cliffs' steamers *Edward B. Greene* and *La Salle* sit out the winter near one of Cleveland's water treatment facilities along the old bed of the Cuyahoga. The *Greene* was constructed in 1952 to be the new flagship for the Cleveland-Cliffs' fleet, a position it held for nine years. The boat eventually ended up with the Interlake Steamship Company in the late 1980s and it still sails today as the *Kaye E. Barker*. (Cleveland Press Archives—CSU Library Special Collections.)

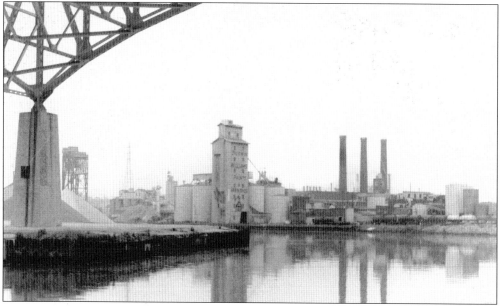

A river's eye view of the Sherwin-Williams Company linseed oil plant. The plant was 64 years old by the time this image was taken in 1966. Although this plant and several other aspects of Sherwin-William's works have since left the Flats, the company still has a research facility along Canal Road near Carter Street. (Cleveland Press Archives—CSU Library Special Collections.)

This is a 1966 view of the New York Central Railroad's freight facility looking southwest from East 22nd Street and Woodland Avenue. Rail historians will note that the New York Central would soon no longer exist as it would merge with the Pennsylvania Railroad to form PennCentral by the year's end. (Cleveland Press Archives—CSU Library Special Collections.)

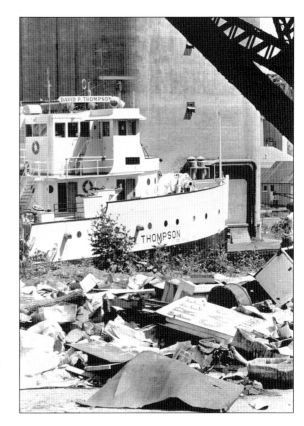

Dumping had always been a problem in the Flats, especially underneath the region's various bridges. An observer watches as the *David P. Thompson* navigates past a trash pile beneath the Detroit-Superior Bridge in the summer of 1966. (Photograph by Paul Teppley; Cleveland Press Archives—CSU Library Special Collections.)

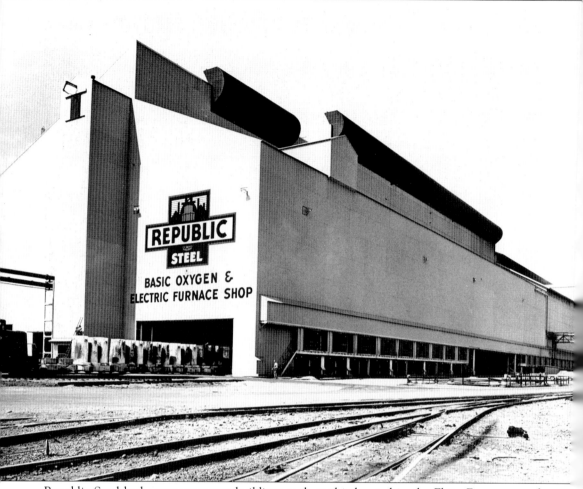

Republic Steel had many enormous buildings such as this located in the Flats. For a sense of scale, note the worker standing near the center of the image. (Cleveland Press Archives—CSU Library Special Collections.)

An oil slick clogs the Cuyahoga just south of a bridge used by the New York Central and St. Louis Railroads. This large jackknife bridge is 255 feet long and has been kept in its raised position for over 35 years. (Photograph by Bill Nehez; Cleveland Press Archives—CSU Library Special Collections.)

Another man's trash . . . While many people would see only garbage, these students from the Cooper Art School see a medium for creating a sculpture. (Photograph by Tom Prusha; Cleveland Press Archives—CSU Library Special Collections.)

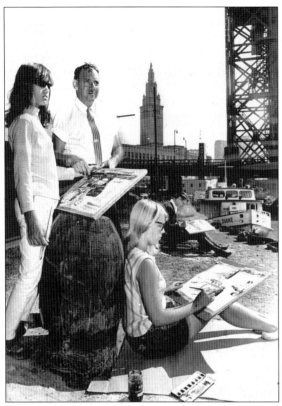

Using a more traditional medium of pencil and paper, Cleveland art teacher Moses Pearl and his students find inspiration near the Carter Street Bridge. (Cleveland Press Archives—CSU Library Special Collections.)

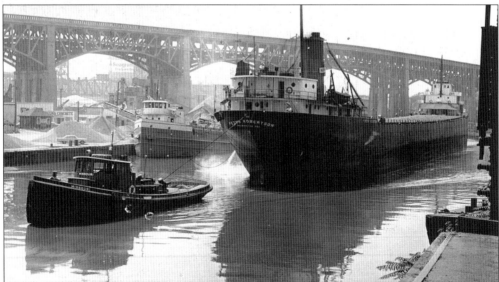

Pictured here is Republic Steel's *Peter Robertson* getting an assist from the Great Lakes tug *Missouri*. The *Robertson*, built in 1906, met an ignoble end in 1969 as it was being towed to Europe for scrapping. The ship broke free of its tug boats and wound up beached near La Coruna, Spain. It eventually snapped in two. In the background, the 147-foot-long *A. G. Breckling* can be seen at a stone dock. (Photograph by Bill Nehez; Cleveland Press Archives—CSU Library Special Collections.)

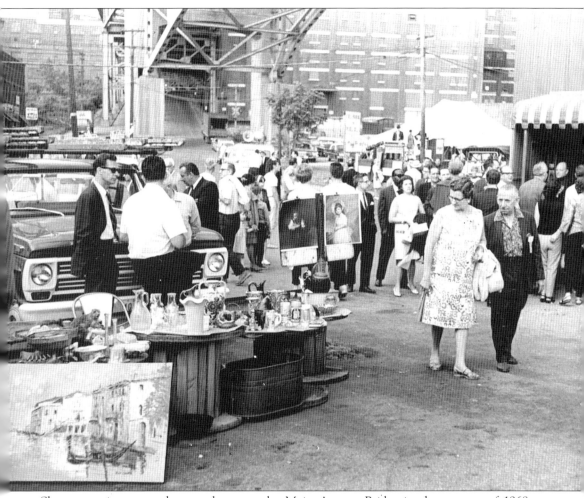

Shoppers enjoy an outdoor market near the Main Avenue Bridge in the summer of 1968. (Photograph by Van Dillard; Cleveland Press Archives—CSU Library Special Collections.)

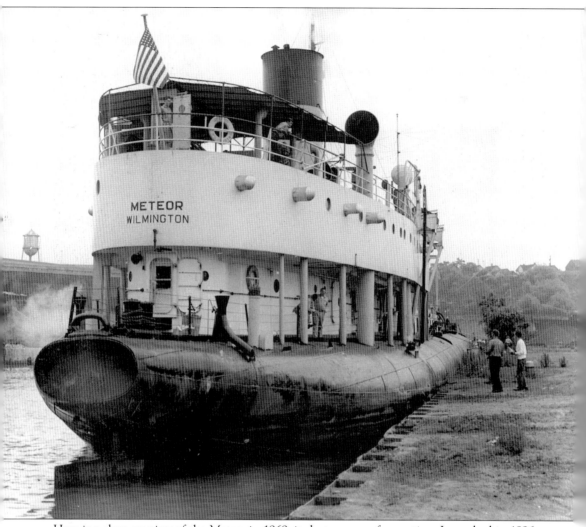

Here is a close-up view of the *Meteor* in 1969, its last season of operation. Launched in 1896 as the *Frank Rockefeller*, this boat was one of several whaleback steamers designed by Alexander McDougal in the late 19th century. Originally a part of the Pittsburg Steamship Company, the ship was eventually bought by Cleveland Tankers in 1943 and converted into an oil tanker. It is now a museum ship in Superior, Wisconsin. (Photograph by Joseph Ostendorff; the Robert Vance Collection.)

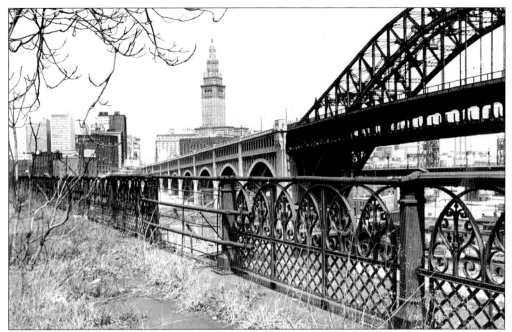

By the 1960s, the remaining section of the Superior Viaduct had fallen into disrepair. Trees grew where carriages and street cars once traveled and the Viaduct's decorative ironwork was left to rust. (Photograph by Frank Aleksandrowicz; Cleveland Press Archives—CSU Library Special Collections.)

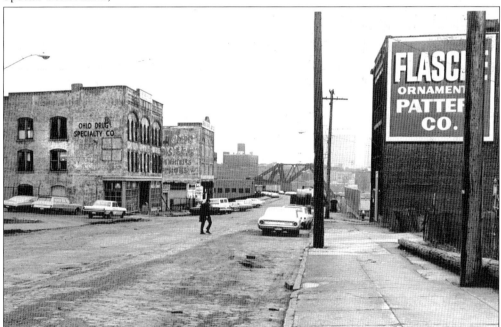

Unfortunately the Superior Viaduct resembled much of Cleveland when this image was taken in 1969. Crumbling buildings and streets were all too common as more residents fled to the city's suburbs, taking Cleveland's tax base with them. (Photograph by Van Dillard; Cleveland Press Archives—CSU Library Special Collections.)

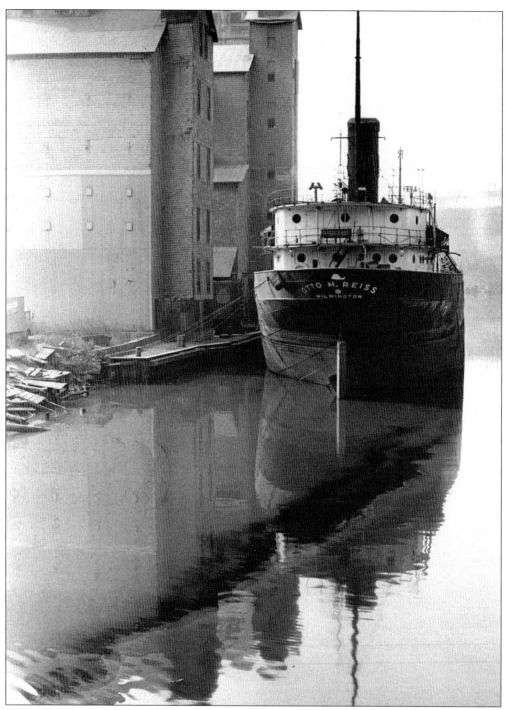

An oil slick floats ominously past the *Otto M. Reiss* in March 1969. This photograph would prove sadly prophetic as another oil slick caught fire along the Cuyahoga three months later. While Clevelanders were used to images of the river in flames, the rest of the country was shocked when photographs of the burning Cuyahoga made their way into the August 1 issue of *Time* magazine. (Photograph by Bill Nehez; Cleveland Press Archives—CSU Library Special Collections.)

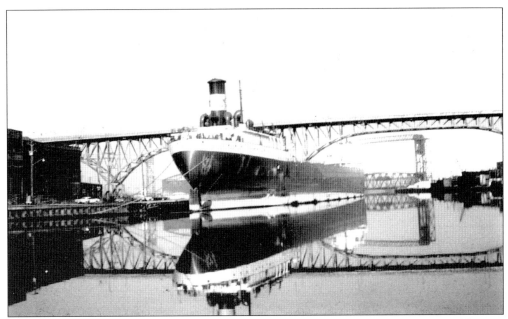

The waters of the Cuyahoga create a nearly perfect mirror image of the steamer *Middletown*. Built in 1943 as the *Neshanic*, this particular boat originally served in the U.S. Navy as an oil tanker. The vessel was converted into a dry bulk carrier in 1961 and lengthened to 730 feet long. Columbia Transportation acquired the ship in 1962 and renamed it *Middletown*. A self-unloading rig was added in 1982, and the boat works on into the present day. (Photograph by Robert Vance.)

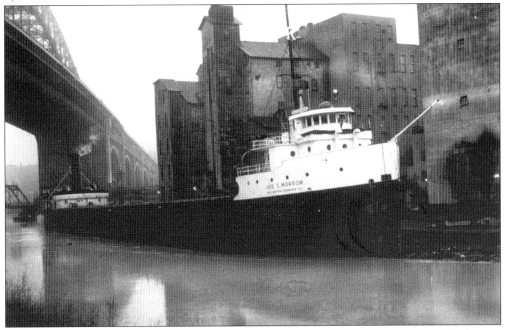

The 420-foot-long *Joe S. Morrow* sailed from 1907 until 1973. Seen here in 1969, the boat is moored at the Montana Flour Mills dock near the Detroit-Superior Bridge. (Photograph by Robert Vance.)

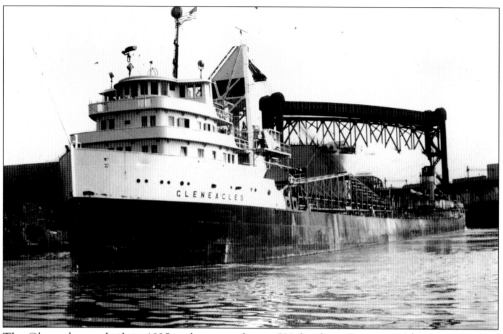

The *Gleneagles* was built in 1925 and measured in at 582 feet long. Fire caused $50,000 worth of damage to her aft deckhouse while laid up six months before this image was taken. The raised bridge in the background is still in use and allows traffic from the Flats Industrial Railroad to cross the river. (Photograph by Robert Vance.)

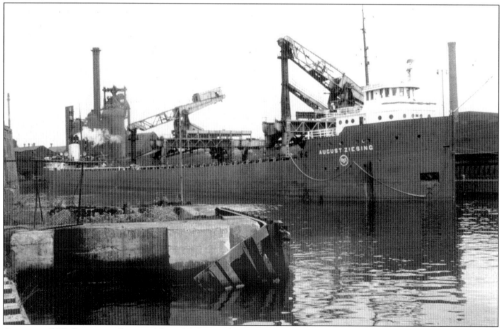

A pair of Huletts, each capable of lifting 10 tons of cargo, unload the *August Ziesing* at U.S. Steel's Central Furnace dock in the summer of 1969. The *Ziesing*, which sailed for U.S. Steel from 1917 until 1984, was among the small number of boats that began and ended its career under the same name and ownership. (Photograph by Robert Vance.)

The *Grand Haven* faced a sad end along the old river bed of the Cuyahoga in June 1969. The 306-foot-long ship had been built in 1903 as a car ferry for the Grand Trunk Car Ferry Line. An outfit based in Honduras bought the ship in 1946 and it sailed in the Caribbean until 1964, when it returned to the Great Lakes. Its second stint on the Inland Seas did not last for long, however, as the ship was laid up for good a year later. (Photograph by Robert Vance.)

The *Grand Haven* sunk in the old flow, three months after the previous image was taken. The boat would be raised, but only so it could be scrapped. And as if the old ship had not been subjected to enough already, it would be ravaged by fire as it was being cut apart. (Photograph by Robert Vance.)

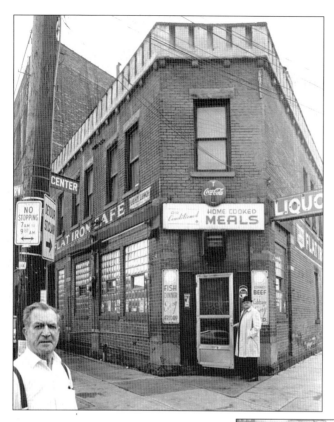

No discussion of the Flats would be complete without the Flat Iron Café. The building itself was once home to a four-story hotel (two stories were lost to fire), and the café would be founded in 1910, making it perhaps the oldest continuous establishment in the Flats. Pictured here in 1967 is Izzy Cohen (left), a long time owner of the Flat Iron who served staples such as corned beef and cabbage to many a hungry Clevelander. (Photograph by Bill Nehez; Cleveland Press Archives—CSU Library Special Collections.)

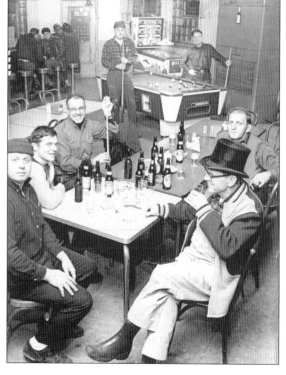

Shown here is a typical cast of characters in the Flat Iron in February 1970. Longshoremen, sailors, and steelworkers were regulars, but one could also find many white-collar types hanging around the Irish café as well. (Photograph by Tom Prusha; Cleveland Press Archives—CSU Library Special Collections.)

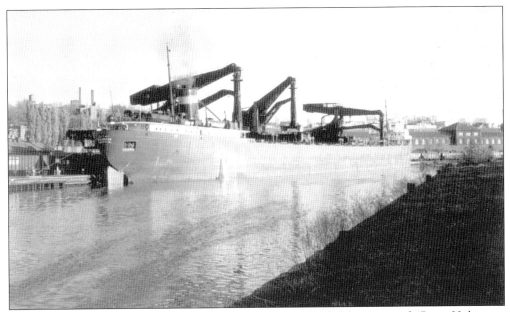

The Interlake Steamship Company's *E. G. Grace* is unloaded by a trio of 17-ton Huletts at the Erie Railroad dock in the spring of 1970. (Photograph by Dave Smith; the Robert Vance Collection.)

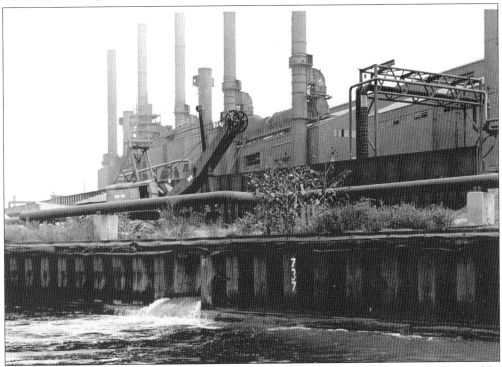

Untreated discharge pours out of Republic Steel into the waters of the Cuyahoga. Scenes like this would not be upsetting if that was simply water flowing into the river. If the image were in color, however, one would see that the liquid is orange. (Photograph by Larry O. Nighswander; Cleveland Press Archives—CSU Library Special Collections.)

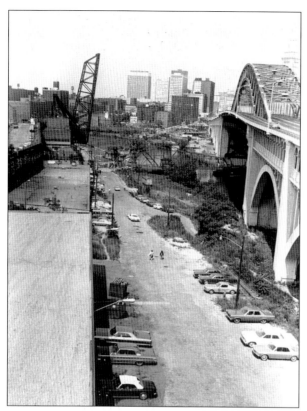

Four bridges share the spotlight in this view looking down Riverbed Street in August 1970: the Superior Viaduct, the New York Central-St. Louis Railroad Bridge, the Center Street swing bridge, and the Detroit-Superior Bridge. (Photograph by Van Dillard; Cleveland Press Archives—CSU Library Special Collections)

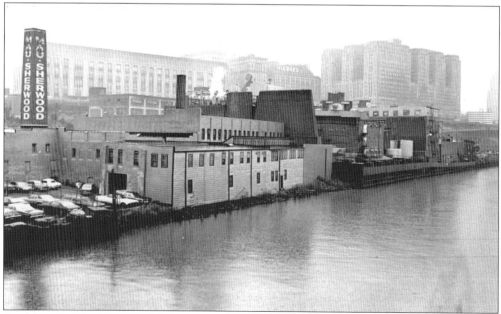

Here are the Mau-Sherwood Company and part of Sherwin-Williams operations in the Flats. Most of the structures seen in this image are now gone, and the space they once occupied now serves as a campus for Sherwin-Williams's research facility. (Photograph by Herman Seid; Cleveland Press Archives—CSU Library Special Collections.)

A look at *Consumers Power* as she waits out winter lay-up in an ice-choked Cuyahoga. *Consumers Power* was once known as the *George M. Humphrey*, and it was under that name in 1943 that the ship sank in 74 feet of water after a collision in the Straits of Mackinac. All 39 of her crew members were rescued and the ship was salvaged. The 586-foot-long vessel would eventually succumb to the shipbreaker's cutting torch in 1988. (Photograph by Glenn Zahn; Cleveland Press Archives—CSU Library Special Collections.)

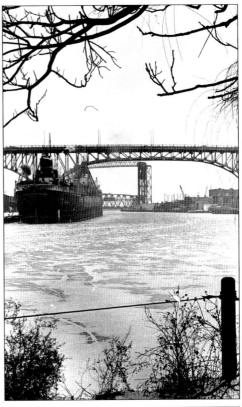

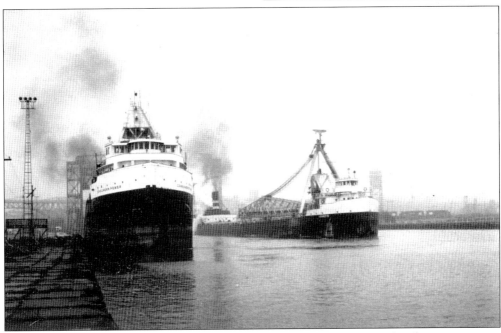

Hennepin, a steamer built in 1905, and *Consumers Power* appear to be drag racing past docks belonging to the Cleveland Stevedore Company in November 1970. (Photograph by Robert Vance.)

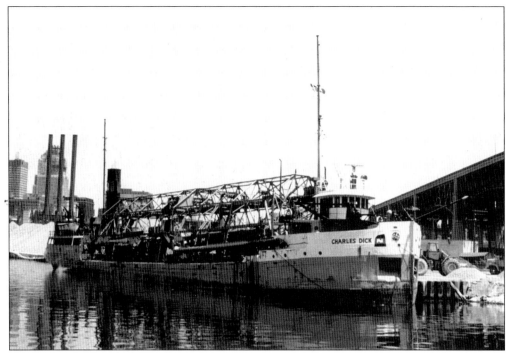

Built in 1922, the *Charles Dick* spent its entire career sailing for Toronto's National Sand and Materials Company, Ltd. Boats such as the *Charles Dick* were designed to draw sand off of lake and river bottoms and were known as sand suckers. The ship was captured here in 1971 as it was docked just north of the Lorain-Carnegie Bridge. (Photograph by Robert Vance.)

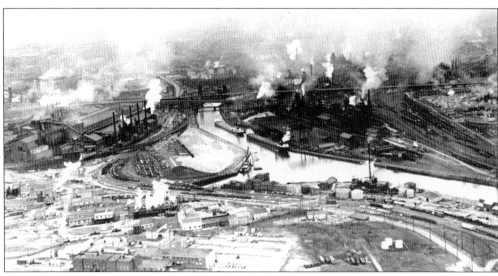

A pair of lake boats is shown at the docks of the Jones and Laughlin Steel Works. At left is Republic Steel. Long time rivals, Republic and Jones and Laughlin would become part of the same operation in 1984 when LTV Corporation (which acquired Jones and Laughlin in 1968) bought Republic. (Photograph by Bernie Noble; Cleveland Press Archives—CSU Library Special Collections.)

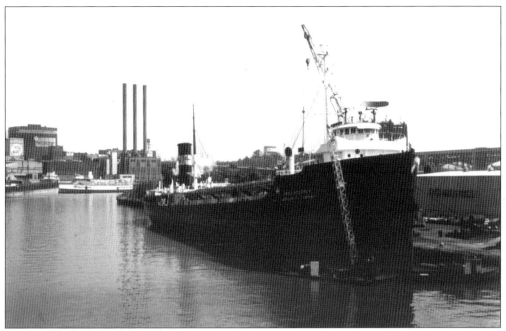

Amoco Wisconsin, an oil tanker built in 1930, undergoes repairs at G&W Industries. Located along Carter Road, G&W Industries was one of several companies that ran repair docks along the Cuyahoga. While G&W Industries is no longer in business, the dock still serves as a lay-up facility. (Photograph by Robert Vance.)

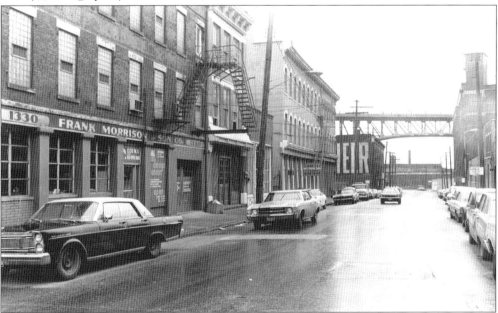

This section of Old River Road was once home to many businesses. As the 1970s wore on, however, many establishments would close leaving the street almost deserted. The area would experience a rebirth in the 1980s, as various trendy bars opened up in the same buildings where industrial supplies and marine fittings were once stored and sold. (Photograph by Clayton Knipper; Cleveland Press Archives —CSU Library Special Collections.)

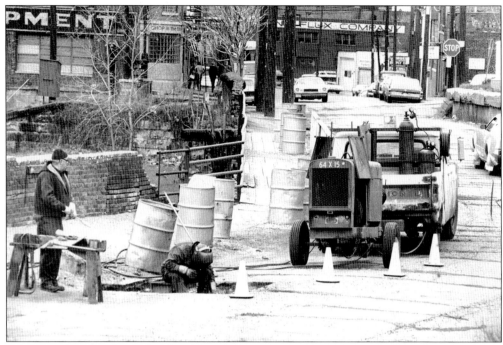

Streets in the Flats have always taken a heavy beating from car and truck traffic. Thus, the ever-present need for maintenance crews such as this one seen in 1973. (Photograph by Timothy Culek; Cleveland Press Archives—CSU Library Special Collections.)

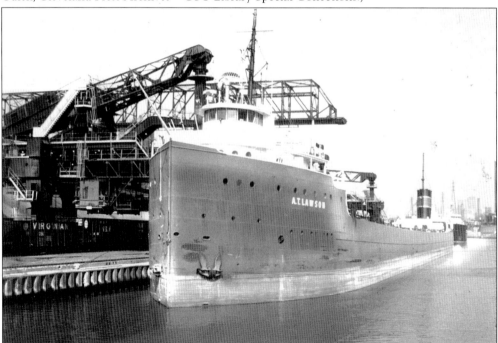

The *A. T. Lawson*, seen here under the Kinsman Marine Transit Company's Flag, unloads at the Lower Republic Steel dock in September 1974. The Huletts at lower Republic were rated for only 10 tons, which made for rather lengthy unload times. (Photograph by Robert Vance.)

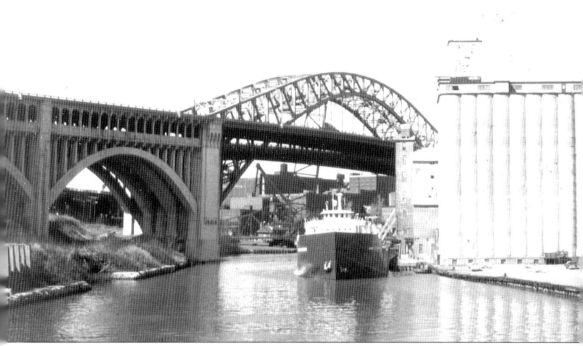

The *James E. Ferris* unloads grain near the Detroit-Superior Bridge in April 1974, just eight months before it was taken out of service. The erstwhile boat had been built in 1910 and spent its final days, before being scrapped in 1979, as a grain storage hulk in Germany. (Photograph by Robert Vance.)

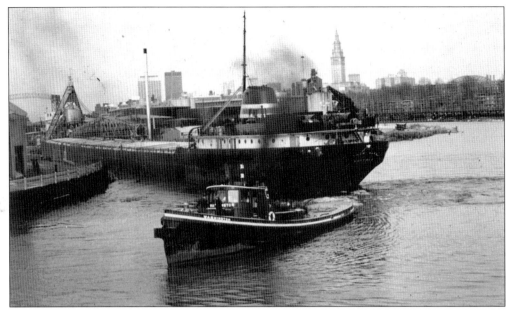

Rock salt has been mined under Lake Erie for decades and Cleveland is one of only two ports on the American side of the Lakes where freighters load salt (the other is Fairport Harbor, Ohio). The salt dock is located along the old river bed of the Cuyahoga and, as this image of the *Diamond Alkali* demonstrates, any lake boat loading there needs assistance from a trusty Great Lakes Towing Company tug to exit. (Photograph by Robert Vance.)

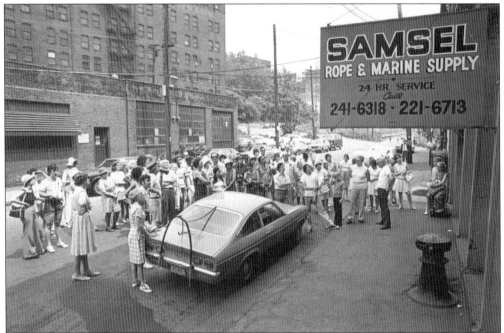

A walking tour of the Flats prepares to step off from the Samsel Supply Company in June 1975. Still in business today, Samsel's is among the last establishments where one can find lines, ladders, and fenders hand-made from ropes and wires. (Cleveland Press Archives—CSU Library Special Collections.)

This view highlights the water treatment system for Republic Steel's 84-inch hot and cold strip mills. (Cleveland Press Archives—CSU Library Special Collections.)

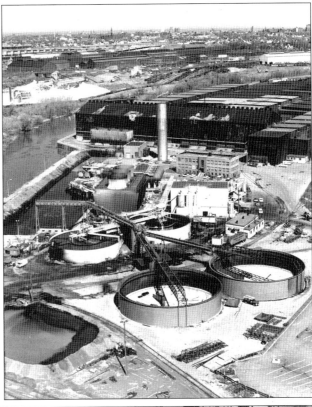

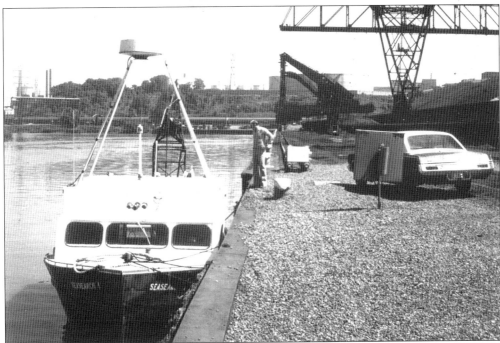

The Upper Republic Steel dock, seen here in 1976 with the *Sea Search I*, marks the furthest point freighters travel up the Cuyahoga. (Photograph by Robert Vance.)

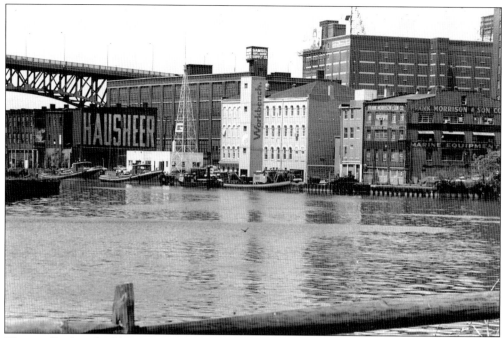

The small white building near the left of this image served as a dispatcher's office for Great Lakes Towing Company (note the radio antenna with the large "G"). Eventually, Great Lakes Towing would move all of its operations to the old river channel of the Cuyahoga. (Photograph by Timothy Culek; Cleveland Press Archives—CSU Library Special Collections.)

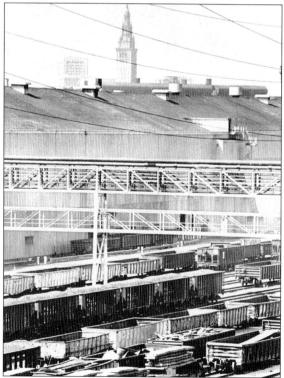

One could get lost quite easily inside the massive complex of buildings and rail lines of Republic Steel. The only reference points for the confused traveler in this instance would be the Justice Center and Terminal Tower, both seen in the background. (Photograph by Larry O. Nighswander; Cleveland Press Archives—CSU Library Special Collections.)

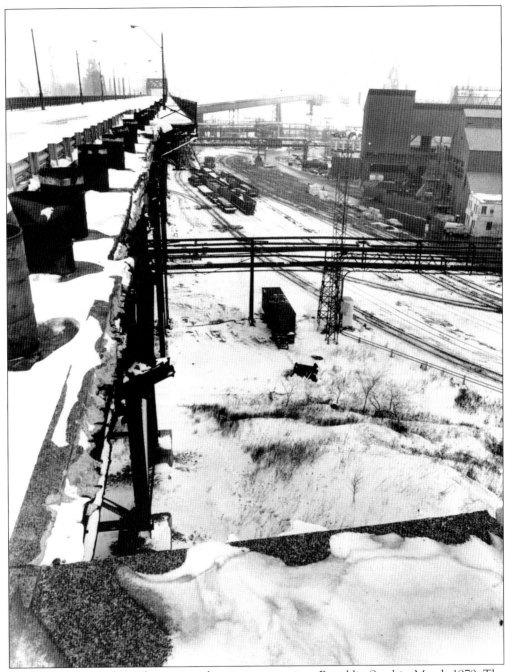

Clark Avenue travels to the west as the viewer peers into Republic Steel in March 1979. The cold of a Cleveland winter can almost be felt by just looking at the image. (Photograph by Bernie Noble; Cleveland Press Archives—CSU Library Special Collections.)

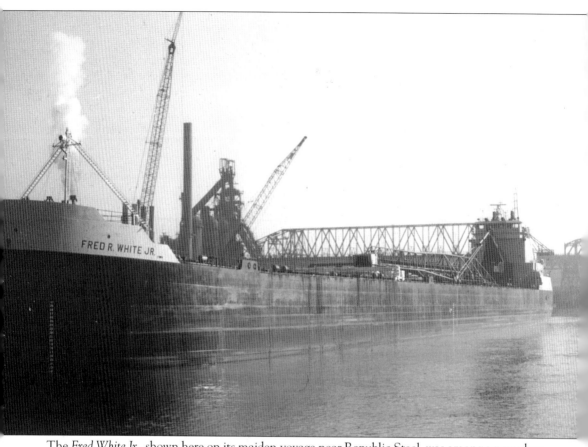

The *Fred White Jr.*, shown here on its maiden voyage near Republic Steel, was among a new class of lake boats constructed in the late 1970s and early 1980s. The primary goal for these "river class" boats was navigating tight rivers and harbors, especially the Cuyahoga. Ships like the *White* tended to be 620 to 630 feet in length and could carry approximately 20,000 tons of cargo. (Photograph by Robert Vance.)

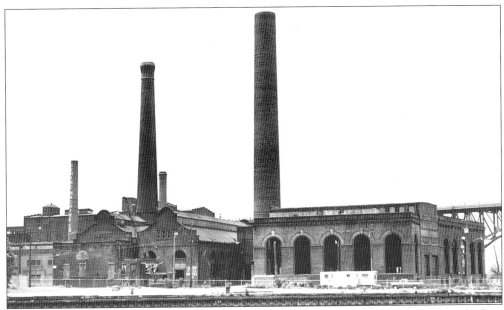

In 1892, Marcus Hannah's Woodland Avenue and Westside Railway Company built a powerhouse to provide electricity for its street cars. By the 1970s, however, the building was nothing more than a brick shell with its roof and windows long since crumbled away. A plan was launched to turn the old building into something resembling San Francisco's Ghiradelli Square or Seattle's Trolley Square. By the end of the 1980s, restaurants, a video arcade, and a comedy club would occupy the space where dynamos used to labor. (Cleveland Press Archives—CSU Library Special Collections.)

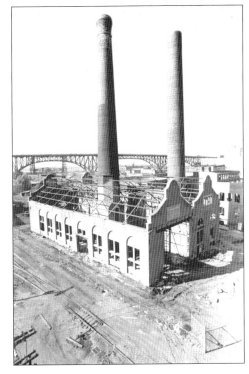

Here is another view of the remains of the powerhouse. (Photograph by Clayton Knipper; Cleveland Press Archives—CSU Library Special Collections.)

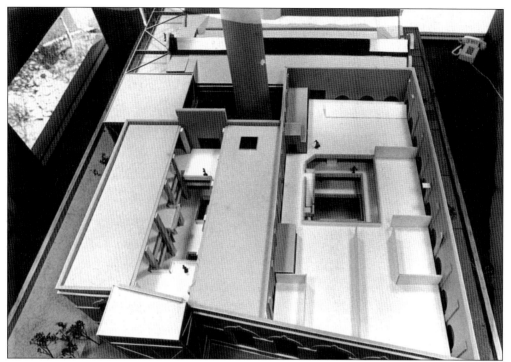

An architect's model of the proposed $5 million powerhouse project. (Cleveland Press Archives—CSU Library Special Collections.)

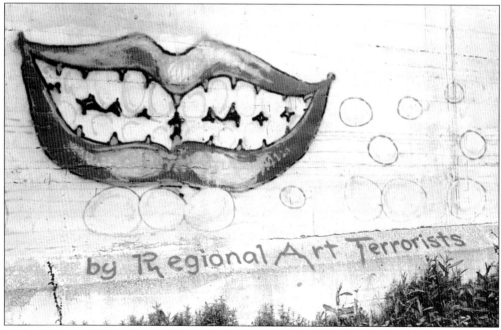

In the 1970s, graffiti artists would use the deteriorating buildings, bridge piers, and transit cars of America's large cities as canvasses for their work. Here an outfit known as the Regional Art Terrorists has left its mark underneath the Detroit-Superior Bridge. (Photograph by Bill Nehez; Cleveland Press Archives—CSU Library Special Collections.)

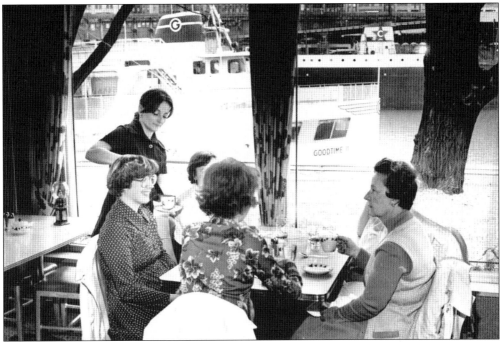

Diners enjoy lunch and a unique view at Jim's Steak House on an early-spring day in 1978. Sitting outside the window is the *Goodtime II* excursion boat which would take passengers on tours of the Cuyahoga and Lake Erie. Moored on the other side of the river is a member of the Columbia Transportation fleet (known now as Oglebay Norton Marine Services). (Photograph by Tom Tomsic; Cleveland Press Archives—CSU Library Special Collections.)

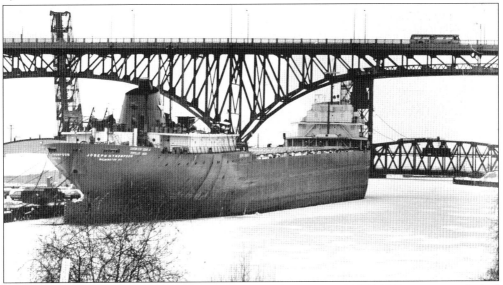

The Hannah fleet's *Joseph H. Thompson* waits out the winter of 1978-1979 on an ice-choked Cuyahoga. The *Thompson* was a particularly interesting vessel to watch as it had started its life as a C-4 cargo ship built for transporting troops during World War II. The *Thompson* and several other former C-4 ships would be converted to Great Lakes freighter in the 1950s. (Photograph by Frank Reed. Cleveland Press Archives—CSU Library Special Collections.)

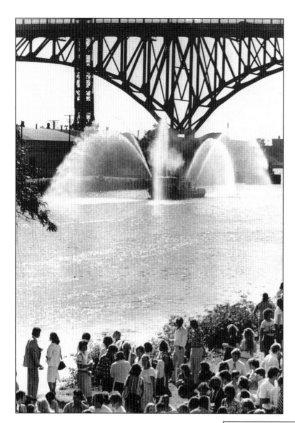

Default, a weakening industrial base, and a continued exodus to the suburbs would all take their toll on Cleveland as the 1970s came to a close. There were some reasons to celebrate however, such as work to clean-up the Cuyahoga and Lake Erie. A group of Clevelanders gather here to mark the 10th anniversary of the infamous 1969 fire along a much cleaner river. (Cleveland Press Archives—CSU Library Special Collections.)

Clevelanders could also take pride in their city's remarkable ethnic diversity. Germans, Irish, Poles, Czechs, and African Americans were only a few of the different backgrounds to be found in the city. A Peoples and Cultures Benefit was held in the Flats in the fall of 1979 to celebrate Cleveland's colorful quilt of ethnicities. Helping to staff the benefit were (front to back) Alicia Ciliberto, Diane M. Ruppelt, Richard Fuerst, and Judy Strauss. (Photograph by Van Dillard; Cleveland Press Archives—CSU Library Special Collections.)

Four

1980–2005

THE FLATS REBORN

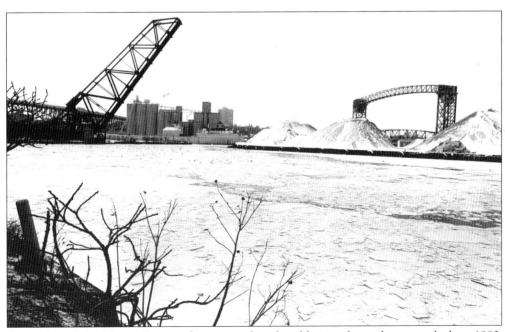

A member of the Huron Cement fleet moored at the old river channel cement dock in 1980. (Cleveland Press Archives—CSU Library Special Collections.)

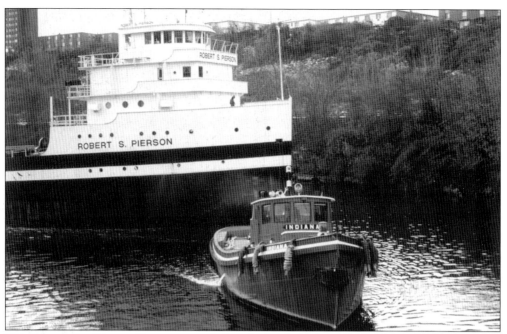

The Great Lakes Towing Company tug *Indiana* helps the *Robert S. Pierson* round the Irish Town Bend. The modern housing projects at the top of the hill are a far cry from the shanties that had previously dotted the area. (Photograph by Robert Vance.)

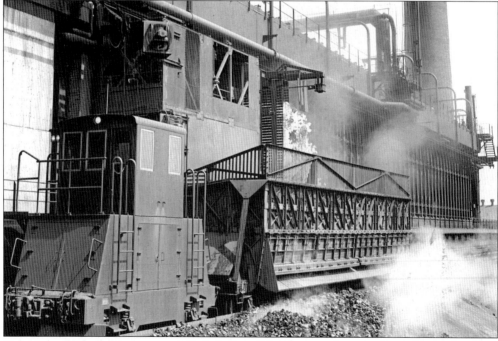

Coke is coal that has been essentially baked until it is not much more than a lump of carbon. Along with iron ore and limestone, it is one of the three major ingredients of steel. This image demonstrates the old method of pushing coke at Republic Steel. Note how much coke dust is released into the air. (Cleveland Press Archives—CSU Library Special Collections.)

In its attempts to control pollution, Republic devised a shroud in the early 1980s, as seen in this image, which would cut down stray coke dust. (Cleveland Press Archives—CSU Library Special Collections.)

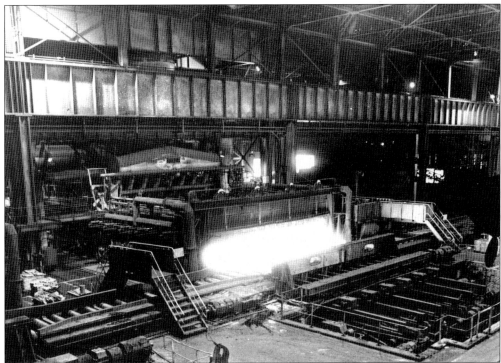

Red hot steel glides along rollers inside Republic Steel's bar mill. (Cleveland Press Archives—CSU Library Special Collections.)

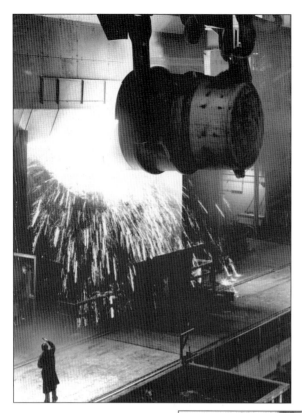

Fresh from a blast furnace at Republic Steel, a load of molten steel is poured into a basic oxygen furnace. The goal of the basic oxygen furnace is to cook out any remaining impurities that may weaken the steel. (Cleveland Press Archives—CSU Library Special Collections.)

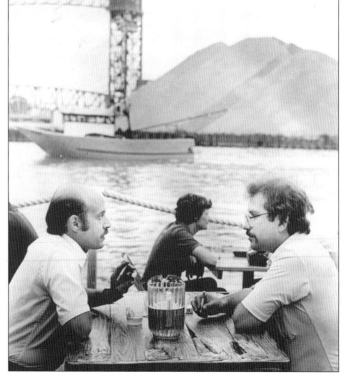

Two men enjoy a beer while sitting along the west bank of the Cuyahoga, near to the river's mouth. The spot where they are is now a restaurant known as Shooters, one of the most popular establishments in the Flats. (Cleveland Press Archives—CSU Library Special Collections.)

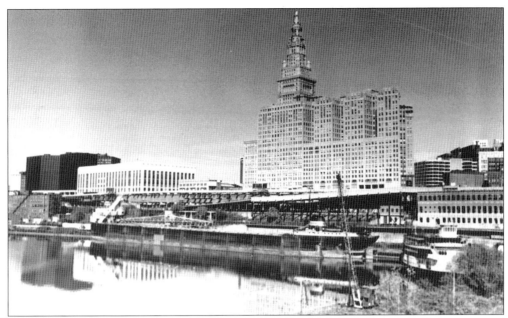

The passenger steamer *Canadiana* sits near the stern of a self-unloader in the late autumn of 1981. The *Canadiana* had been built in 1910 for the Lake Erie Excursion Company to carry passengers from Buffalo, New York, to an amusement park known as Crystal Beach in Canada. The ship stopped sailing in 1958 and eventually ended up on the Cuyahoga. (Photograph by Bernie Noble; Cleveland Press Archives—CSU Library Special Collections.)

Some of Cleveland's visionaries felt that the *Canadiana* would make a fabulous floating restaurant. Such plans had to be abandoned when the old steamer broke from her moorings and sank early in 1982. The ship was eventually raised and towed to Ashtabula, Ohio. (Photograph by Robert Vance.)

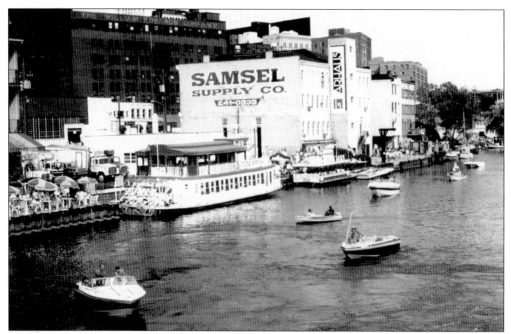

Throughout the 1980s, a series of festivals known as riverfests were held along the Cuyahoga. A carnival atmosphere could be found on shore while pleasure boaters sailed up and down the river. Contests were held to see who could devise the most outlandish vessel that could still remain afloat and a parade of lighted boats would serve as the highlight of the festivities. Two water taxis, the *Pride of Cleveland* and the *Holy Moses* (named after Moses Cleaveland), prepare to take festival goers out onto the river. (Photograph by Robert Vance.)

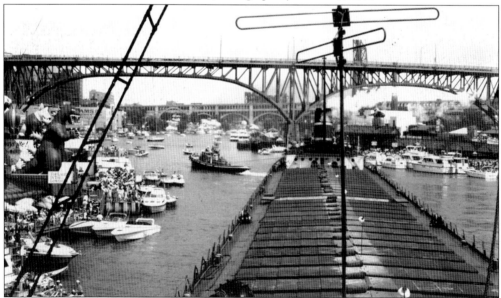

Old and new mingle in this image of the 1988 Riverfest taken from the steamer *Henry Steinbrenner*. The 580-foot-long *Steinbrenner* was built in 1916 (then known as the *William A. McGonagle*) and it had the distinction of being among the last coal-fired steamboats left on the lakes when it was scrapped in 1994. (Photograph by Robert Vance.)

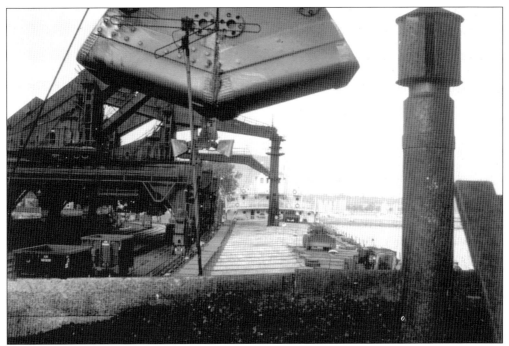

A dramatic shot of the four Huletts located at the Cleveland & Pittsburgh Dock on Whiskey Island unloading the *Henry Steinbrenner*. This set of 17-ton Huletts would be the last to operate in Cleveland when they were shut down in 1992. Preservationists fought a losing battle to save the Huletts from dismantling, but hope remains that one or possibly two of these remarkable machines may be rebuilt as part of a public park. (Photograph by Robert Vance.)

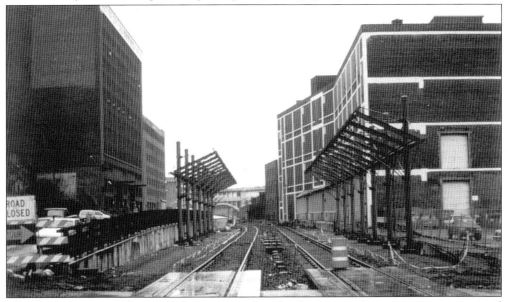

Cleveland's Regional Transit Authority elected to develop a waterfront extension to its rapid transit system in the early 1990s. The new line would start in the Terminal Tower and descend through the Flats on its way to the city's lakefront. Shown here under construction is the Waterfront Line's East Bank Station. (Photograph by Robert Vance.)

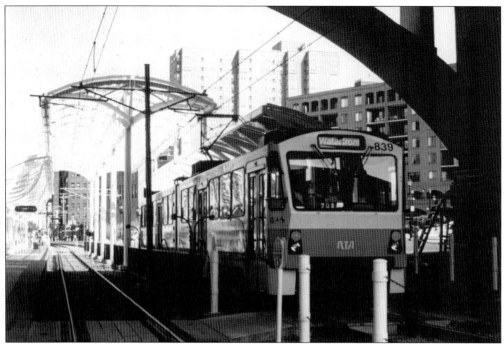

A Waterfront Line train pulls into the just completed Settler's Landing Station on its way to the Terminal Tower. (Photograph by Robert Vance.)

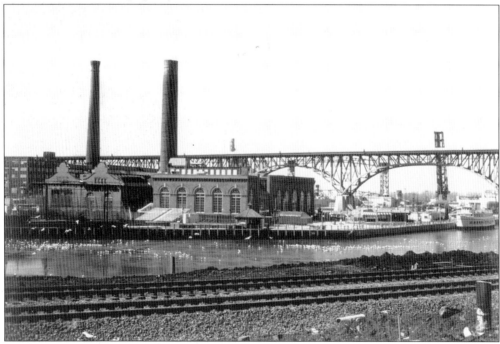

The Powerhouse complex got a new neighbor in the 1990s as the Nautica Stage was erected to hold live musical performances. Docked to the north of the Powerhouse is the *Nautica Queen*, an excursion boat that provides dinner cruises along the Cuyahoga and Lake Erie. (Photograph by Robert Vance.)

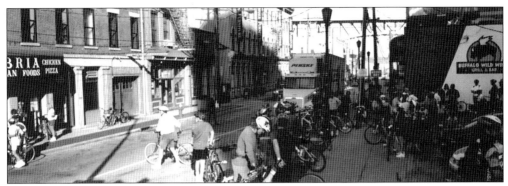

Riders prepare for an annual bicycle ride known as the Urban Enduro Tour o' Cleveland, which begins and ends in the Flats. A 25-mile trek around the city's west side, the Enduro is a chance for cyclists of all stripes to enjoy a non-competitive ride. (Photograph by the author.)

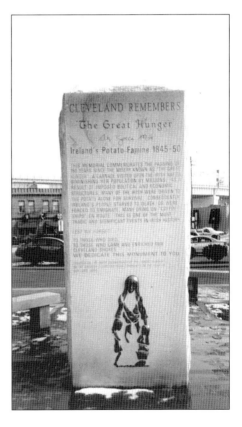

Like many cities in the north and east, Cleveland would be a refuge for numerous victims of Ireland's potato famine of the 1840s. Cleveland's Irish-American community commissioned this monument in 2000 to commemorate the 150th anniversary of the famine. (Photograph by the author.)

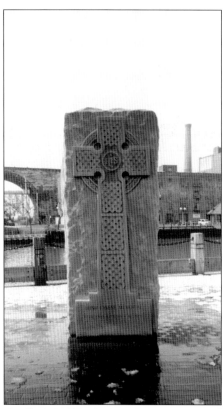

This is the opposite side of the monument. The remains of the Superior Viaduct are seen in the background to the left. (Photograph by the author.)

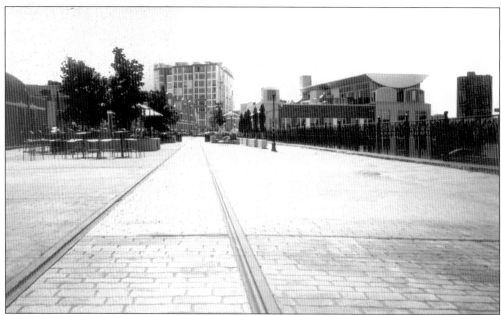

Rescued from decay, the deck of the Superior Viaduct now serves as a promenade for luxury apartments, condominiums, a restaurant, and a Cuyahoga County Engineer's office. The street car tracks, once covered in weeds, can again be seen traveling to the west. (Photograph by the author.)

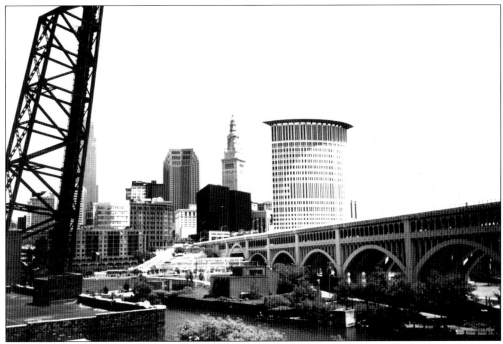

Modern downtown Cleveland as seen from the Flats. The glass canopies in the center of the image cover the Settlers' Landing stop along the city's waterfront transit line. (Photograph by the author.)

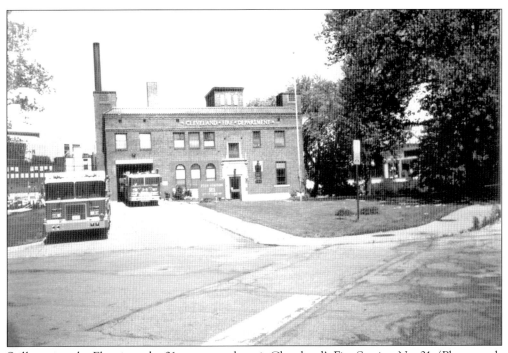

Still serving the Flats into the 21st century, here is Cleveland's Fire Station No. 21. (Photograph by the author.)

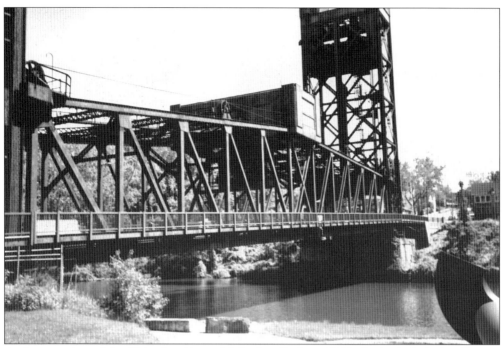

A close-up view of the Columbus Street lift bridge. Built in 1940, the bridge's deck will most likely be replaced some time in the near future. (Photograph by the author.)

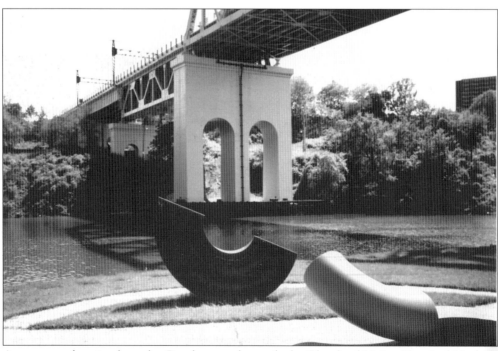

A poetry garden sits along the Cuyahoga underneath the Cleveland Union Terminal Viaduct, just to the north of the Columbus Street Bridge. Various pieces of sculpture are emblazoned with verses that reflect Cleveland's history as a port and industrial city. (Photograph by the author.)

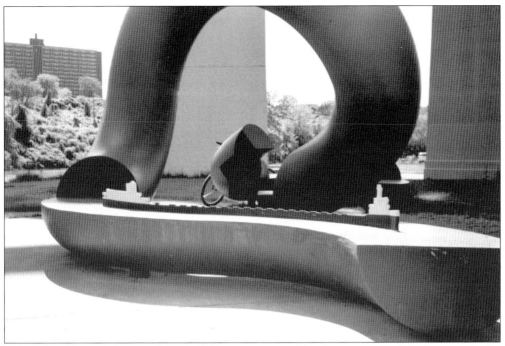

The challenge of navigating the Cuyahoga is represented by this serpentine lake boat inside the Columbus Street Poetry Garden. (Photograph by the author.)

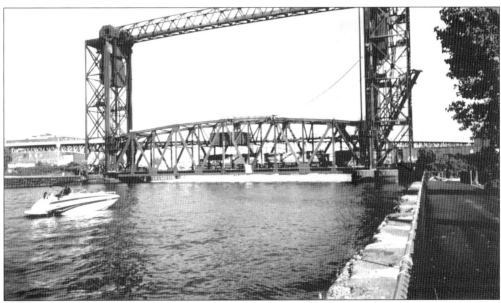

Now owned by the Norfolk and Southern Railroad, the trestle spanning the mouth of the Cuyahoga hosts a constant stream of train traffic, much to the frustration of pleasure boaters. (Photograph by the author.)

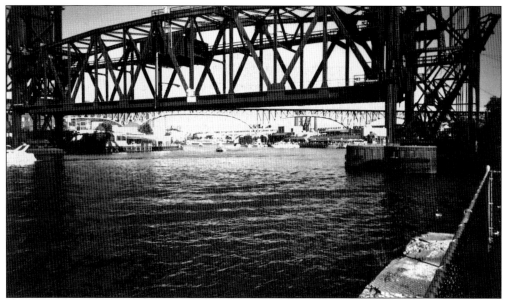

Once a freight train is cleared of the trestle, boaters can continue their voyages along the Cuyahoga. (Photograph by the author.)

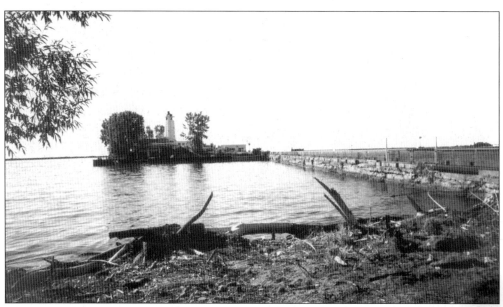

Cleveland's old Coast Guard station keeps a silent vigil over Lake Erie from its post just off of Whiskey Island. The city owns the vacant station (the Coast Guard now has its operations to the east of the river), and there is hope of restoring the building and allowing public access. (Photograph by the author.)

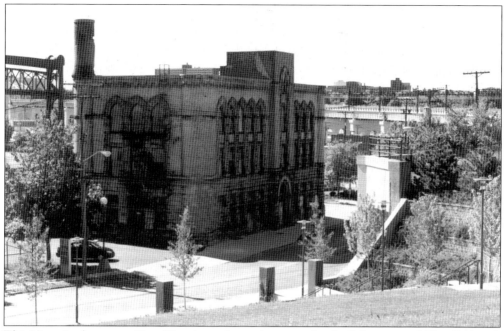

This Victorian beauty on Canal Road once housed a station for the Baltimore and Ohio Railroad. It now sits vacant, but a group of local historians hopes to convert the building into a museum. (Photograph by the author.)

Shown here is Sherwin-Williams's gleaming John G. Breen Technology Center. (Photograph by the author.)

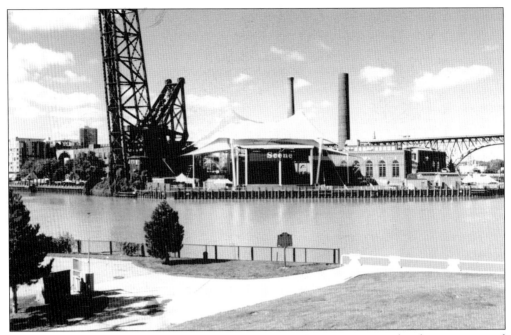

The Nautica stage would eventually gain an awning and a new name. A local news, arts, and entertainment magazine bought the naming rights and the venue is currently known as the Scene Pavilion. (Photograph by the author.)

Old River Road was the place to be on any given Saturday night throughout the late 1980s and early 1990s. Too much public intoxication (including several unfortunate drowning incidents in the Cuyahoga) and changing tastes have left the East Bank a shadow of its former self, as many bars have shut down. A local developer has bought much of the property in the area, however, and there are plans to build a new mix of residential and commercial sites. (Photograph by the author.)

The party is not completely over on the East Bank though, as several establishments, such as the Beachcomber, still offer good times along the "Crooked River." (Photograph by the author.)

The Odeon Concert Club, located at the end of Old River Road, plays host to dozens of musical acts every year. (Photograph by the author.)

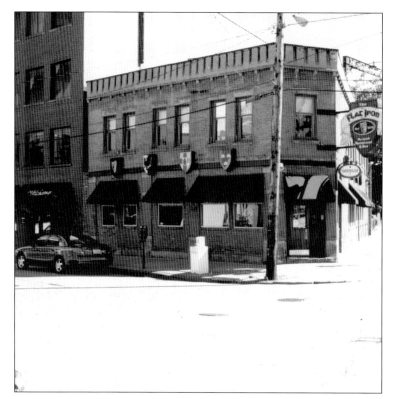

Here is the venerable Flat Iron Café as it appears today. Although some old-timers feel the place is not quite as colorful as in years past, one can still find a hearty meal in a friendly atmosphere. (Photograph by the author.)

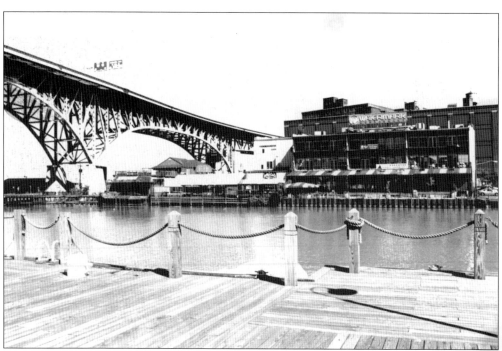

A modern view of the East Bank with the Main Avenue Bridge to the left. (Photograph by the author.)

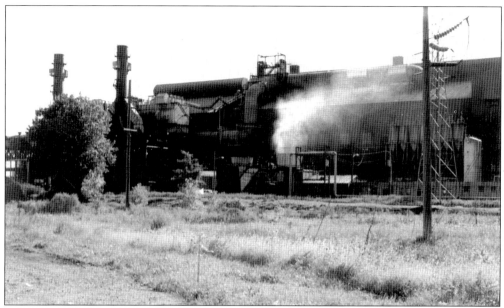

Steel production in the Flats would experience a death and rebirth in the last two decades of the 20th century. LTV Corporation, which purchased Republic Steel in 1984, declared bankruptcy in 1986. The company tried to soldier on, but was unable to survive into the new millennium. While LTV was dealing with its creditors, steel making in the Flats actually ceased for a short time. Fortunately a new company named International Steel Group (ISG) would take over LTVs former holdings and restart the furnaces. The ISG name is also on the way out, but not because of failure. Mittal Steel, the world's largest steel maker, bought out ISG thus adding the Cleveland works to its massive empire. (Photograph by the author.)

The physical layout of Cleveland's steel-making facilities has undergone drastic changes in recent times. Many sections of the plant on the west side of the Cuyahoga were razed as ISG attempted to restructure its operations. Massive buildings once stood in this vast field of dirt. The land is not to go to waste, however, as retail development known as Steel Yard Commons is scheduled to be built in the area. (Photograph by the author.)

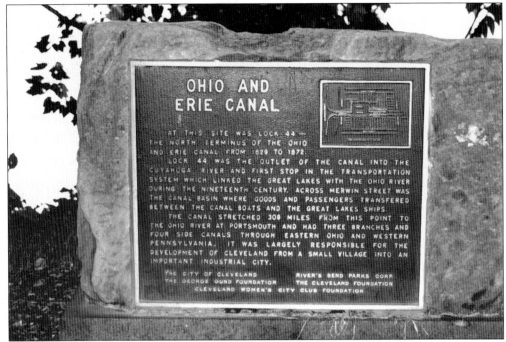

While portions of the Ohio and Erie Canal to the south of Cleveland can be easily found, it takes some perseverance to hunt down the remains of the canal's northern end. This situation should be remedied in the near future with the creation of the proposed Canal Basin Park, which would be quite close to this marker. (Photograph by the author.)

Before blast furnaces, before oil refineries, and before mammoth steel ships roamed the Flats, there was a simple log cabin. This structure is a replica of the cabin that Lorenzo Carter built in the late 18th century. Carter would be the area's first permanent white settler, but since Moses Cleaveland had arrived first, this particular sector of the Western Reserve took his name (minus a letter "A", however). (Photograph by the author.)